12/02

14x

EAST AFRICA

East Africa

AN EVOLVING LANDSCAPE

Tim Beddow

Introduction by Dominic Sasse

with 78 color illustrations

THAMES AND HUDSON

First published in the United States in 1988 by Thames and Hudson Inc., 500 Fifth Avenue, New York, New York 10110

Library of Congress Catalog Card Number 87-51287

Printed and bound in Singapore by C.S. Graphics

CONTENTS

For Totty and Kiloran

Acknowledgments

*I would like to thank the following people for their help and
kindness in many different ways during the making of this book:*

Mr & Mrs M. Barker, Nairobi
Mr T. Bentley-Buckle, Beaulieu
Mr R. Brennecke, Deutsche Afrika-Linien, Hamburg
Abdi Yussuf Dirir, Nairobi
Charles Dobie, Dar es Salaam
Alan DuFresne, Lake Baringo
Mr & Mrs G. Fox, Mafinga
Andrew Hall, Mombasa and Zanzibar
Mustansir Inayathussein, Transit Ltd, Dar es Salaam
Ilford Photo Company, London
Anthea Knagg, Island Camp, Baringo
Mr Machele, Tanzania Tourist Corporation, Dar es Salaam
Wendy Megson, Island Camp, Baringo
Kazungu Mitingi, Mombasa
Abdullahi Dool Mohamed, Somali Embassy, London
Mr & Mrs J. Niblett, Brooke Bond Estates, Mafinga
Miss M. Pinto, Nairobi
Mr Ramaiya, Zanzibar
Elisabeth Ryrie, Nairobi
Mr & Mrs C. Scott, Tukuyu
Miss Pam Scott, Rongai
Abdi Mohamed Shire, Somali Embassy, Nairobi
George Stephenson, Nairobi
Edward Thoya, Mombasa
Giles Trotter, London
Mr A. Vyas, Shah & Partners, Mombasa
Mr S. Vyas, Shah & Partners, Mombasa
Mr H. Vora, Shah & Partners, Mombasa
Nicholas Wanyamoe, Maralal
Tim Ward-Booth, Lake Baringo
Lastly, my faithful Land-Rover which never let me down.

INTRODUCTION

On the Coast of the Zenj

The dense and steaming forests of the Congo, the arid and inhospitable wastes of the Sudan and Somalia, and the high barren mountains of Ethiopia have for centuries acted as a protective shield—or shell—making it difficult, if not impossible, to reach East Africa overland. Not until recent history did this hostile topography allow any European contact with the interior. The Sahara Desert blocked an approach from the north, the swamp-like Sudd stopped any passage farther south down the Nile, and the equatorial climate in league with the diseased tsetse fly prevented penetration from the west. Because of these considerable natural barriers, invasion, exploration and trade had necessarily to come from a different quarter. The only possible route was from the east, via the vulnerable seaboard where the iridescent Indian Ocean rides in over coral reefs to meet the vast African continent. And so it was here, along the littoral which curves from the mangrove forests of Mozambique to the sand dunes of Mogadishu, that some intrepid sea captain, blown by the monsoon, first jumped ashore to discover the lush and tropical coast of East Africa.

The Phoenicians came before the birth of Christ and later the Egyptians and the Greeks. The *Periplus of the Erithrean Sea*, written in the second century AD, mentions a number of places by their Greek names, such as the Pyralaon Islands which would seem to refer to the Lamu archipelago.

However, it was the Arabs in their ocean-going dhows who, from the seventh century onwards, were to dominate and exploit this particular coast which was known to them as the Coast of Zenj, or Land of the Blacks. Arab navigators, already conversant with algebra and astronomy, quickly realized that their dhows could be blown south from Oman in December when the monsoon starts and driven back to the Gulf of Aden by the same wind a few months later. The auspicious direction of these winds prompted a coastal trade that was soon connected to the larger commercial system of the Indian Ocean, with its links to Malaysia and beyond to China. Natural harbours such as Kilwa, Zanzibar, Mombasa, Malindi and Lamu were obvious choices for their protected positions and deep anchorages. At these and other sites,

ports were built to service the ships as they arrived with their cargoes of grain, oil, sugar and cotton cloth to exchange for cinnamon, frankincense, ivory, skins and iron.

As trade flourished, settlements evolved and Arab, Indian and Persian settlers, some of whom were religious or political refugees, gave them a cosmopolitan character that the interior lacked. They fashioned and fortified their towns from the local rough grey coral rag and, copying Islamic architectural designs from memory, they embellished their houses with decorated plasterwork interiors and elaborate carved doorways. Using mangrove poles as roof supports and coral lime as mortar, these zealous Moslems also built many mosques, all of which have their *mihrabs* dutifully pointing towards Mecca. From these original settlements they spread their Mohammedan faith wherever they travelled and traded, for, as the Koran states, "There is one God (Allah) and Mohammed is his prophet."

Inevitably they intermarried with the local broad-nosed and thick-lipped Bantu. The descendants of this fusion became known as the Swahili—a rough Arabic translation for people of the coast. Their ensuing culture flowered unchecked, enjoying a wide reputation in the medieval world for wealth, comfort and finery. Duarte Barbosa, a Portuguese traveller writing at the beginning of the sixteenth century, reported:

> There is a City of the Moors, called Bombaze [Mombasa] very large and beautiful, and built of high and handsome houses of stone and whitewash and with very good streets . . . and it also has a King over it. The people are of dusky white and brown complexions, and likewise the women, who are much adorned with silks and gold stuffs—this Mombasa is a country well supplied with plenty of provisions, very fine sheep which have round tails and many cows, chickens and very large goats, much rice and millet and plenty of oranges sweet and bitter, and lemons, cedrats, pomegranates, Indian figs, and all sorts of vegetables, and very good water.

The European thrust for expansion and greed for the wealth of this new world could not be stalled for ever. Once Vasco da Gama had found his route to the Spice Islands of the east by rounding the Cape of Good Hope in 1498, Portuguese naval expeditions predictably followed. Over the next fifteen years these merchant-explorers imposed their will by ruthless military conquest, an easy task considering their superior weaponry and firepower. Although they then controlled the coast for roughly two hundred years, few signs of a Portuguese colonial presence remain, except the imposing Fort Jesus in Mombasa, and the sport of bull fighting on Pemba where, as in Portugal, the death of the bull is not demanded.

The Portuguese were finally ousted by the forces of the Sultan of Oman, to whom the Swahili city states had appealed for assistance. Once again Arab rule was restored and trade revived; it was not the traditional exports such as spices, tortoiseshell and aromatic gums which now attracted the traders, but a much more profitable human commodity—slaves.

Throughout their varied history, the trading settlements and independent city states of the Swahili coast had always sold slaves to the domestic markets of Arabia and the Persian Gulf. Indeed, the existence of a slave market in Oman is mentioned as early as the mid-tenth century in a Persian account which reports that the slaves were sold for prices of up to thirty dirhems per head. Contemporary Arab historians also write of large numbers of black slaves employed to scrape "mountains of salt" from the land surrounding Basrah.

Once they had been caught, or willingly exchanged by their local chiefs in return for guns and cloth, these slaves would be taken back along the ancient caravan routes to the sea. They would be processed and sorted either at Bagamoyo or Pangani on the mainland before sale in the market on the island of Zanzibar which lay opposite, some miles off the coast.

In her justly famous book *Out of Africa*, Karen Blixen wrote:

> The dhows of the traders knew all the central fairways and trod the blue paths to the central market place of Zanzibar. They were familiar with it at the time Aladdin sent to the Sultan four hundred black slaves loaded with jewels … probably as these great merchants grew rich, they brought their harems with them to Mombasa and Kalifi, and themselves remained in their villas, by the long white breakers of the ocean and the flowering flaming trees, while they sent their expeditions up into the highlands.

By the turn of the nineteenth century, this still relatively minor trade had increased dramatically to meet the demands of the coffee estates in the French Caribbean and the local clove plantations on Zanzibar and her sister island Pemba, all of which depended on slave labour.

Eagerly sought after both as a preservative and as a medicine, cloves were introduced by Sultan Seyyid Said who, to set an example, ordered forty-five of his own plantations to be sown with this new crop. Traditionally cloves had been grown only in the East Indies; now 60 per cent of the world's supply is produced from Zanzibar and its neighbours.

In 1806, at the age of fifteen, the same Seyyid Said had (in true Arab fashion) murdered his rival to the throne of Oman. Having thus secured his own claim, he next consolidated his position at home before turning his attention to Africa where, since his ancestors had freed the coast from the Portuguese, the Sultan of Oman had ceased to have any real authority. Various rival factions, including the Mazrui family who ruled Mombasa, were vying for supremacy and it was their internal feuds, plus an obvious desire to monopolize the lucrative slave trade, that made Seyyid Said decide to transfer his capital from Muscat to Zanzibar. From here he quickly attacked and conquered Mombasa and within a couple of years had regained control of the whole coast.

During his reign, Zanzibar became the most important city on the coast, growing rich and fat on the profits of slavery. For although the trade was dying out on the Atlantic west coast (which had once been the chief source of Negroes), slavery on the east coast was still in its heyday and the market in Zanzibar was as crowded as ever. When a British research ship *Ternate* stopped here in 1811 its captain, Thomas Smee, observed:

> The show commences about four o'clock in the afternoon. The slaves set off to the best advantage by having their skins cleaned and burnished with cocoa-nut oil, their faces painted with red and white stripes, which is here esteemed elegance, and the hands, noses, ears and feet ornamented with a profusion of bracelets of gold and silver and jewels, are ranged in line, commencing with the youngest and increasing to the rear according to their size and age.

To satisfy an apparently undiminishing demand, Seyyid Said sent more and larger caravans farther inland through the coastal forest, the thornscrub and the tall grasslands to raid the defenceless mud hut villages of the interior. Months later they would return with a long line of slaves yoked together, carrying on their heads elephant tusks and bundles of cloth, beads and grain. By the middle of the nineteenth century nearly 40,000 slaves a year passed through the open market in Zanzibar. A third were kept to work the clove plantations and the rest were exported.

By 1856 conditions had obviously changed, for Richard Burton, the great linguist, Arab scholar and explorer, described the slave markets rather differently:

> Lines of negroes stood like beasts, the broker calling out "Bazar Khush"—the least hideous of the black faces, some of which appeared hardly human, were surmounted by scarlet nightcaps. All were horribly thin, with ribs protruding like the

circles of a cask, and not a few squatted sick on the ground. The most interesting were the small boys, who grinned as if somewhat pleased by the degrading and hardly decent inspection to which both sexes of all ages were subjected. The woman-show appeared poor and miserable, there was only one decent looking girl, with carefully blacked eyebrows.

Reports such as these, sent home by the early travellers, fuelled a widespread desire in Europe to see the end to slavery—still legal in most countries even though it had been abolished within the British Empire in the 1830s. After Sultan Seyyid Said's death, Zanzibar gradually succumbed to the British, whose navy now patrolled the entire Indian Ocean. Even so, it was nearly another twenty years before Britain chose in 1873 to use her political pressure and force Sultan Seyyid Barghash to close the slave market. On this site was built the first Anglican cathedral in Africa, a worthy monument to Western guilt and conscience. Inside this Cathedral Church of Christ, on the left of the chancel, is an outstretched crucifix carved from the wood of the tree beneath which Dr Livingstone died after a lifetime's struggle to make his "black children" worship a white man's God.

Since the revolution of 1964 the merchants have returned either to Oman or to the other Arab states while the present Sultan lives as an incongruous exile in demure Southsea, England. Yet the sensible Victorian spire of Zanzibar's cathedral still rises serene and untroubled above the surrounding maze of twisting streets. This old stone town of rag-coral houses, chequered by alternate sunlight and shadow, drowses now in tropical decay, secret and decadent, hidden behind latticed windows and stern quotations from the Koran carved into arched and studded doorways. It reeks of a dissolute past, sweetened only by the heavy scent of cloves and cardamom.

As the sun sets and dissolves, sharpening the neo-classical outline of the Sultan's four-storeyed palace, women veiled in black like monochrome silhouettes walk up and down with henna-painted feet, while old men in long white Kanzu robes and embroidered skullcaps gather on the waterfront to sit and watch the ships pass by.

Although motorized vessels are now more common, occasionally one of the larger dhows, or *jahazis* as they should properly be called, glides silently past carrying a simple cargo of timber, cement and cashew nuts. As the wind fills its lateen-rigged sails, it tacks along the Tanzanian coast, pushing its raised prow over the coral reefs where angel fish and damsel fish feed. As the limpid waters of the Indian Ocean wash up on to the white sand contours of the mainland, you will see, as Karen Blixen described,

…amongst the old light grey baobab trees—which look not like any earthly kind of vegetation but like porous fossilizations, gigantic belemnites—grey stone ruins of houses, minarets and wells. The same sort of ruins are to be found all the way up the coast, at Takaunga, Kalifi and Lamu. They are remnants of the towns of the ancient Arab traders in ivory and slaves.

This sense of an irrevocable past continues to linger and haunt the coast, regardless of the inevitable changes brought by twentieth-century commercialism and the dubious benefits of the tourist trade.

Even on the island of Lamu, which is now a romantic venue for itinerant hippies where German girls bask naked in the sand dunes and ageing European homosexuals live in sin with their houseboys, it is still possible in the cramped back streets of the coral-stone town to recapture the relics of a medieval consciousness. Open sewers foul the air and vermilion bougainvillaea spills over ornate balconies; donkeys laden with mangrove-poles trot unattended, barging through the idle crowd. Within dim low-ceilinged interiors, faltering, flickering electricity reveals goldsmiths, wood carvers and tailors as they squat, bent over their delicate tasks. Down by the old sea wall, white moon-flowers trumpet over rusting cannon while gossiping fishermen pause to spit. And then, as Laurens van der Post describes it, when tropical night falls like a curtain sown with stars, "…the moon comes up in Africa, the release from tyranny of the sun, the coolness, the beauty of the night takes place and the noises of a new and utterly different sort of life come out of the night."

To the Mountains of the Moon

By the middle of the nineteenth century the East African coast, because of its important position on the sea routes to India and the Orient, was well charted, but the interior was still virtually unmapped. Up to then no white man had ventured inland. Since the time of Ancient Egypt the course of the Nile valley was known to run from the Mediterranean as far as the present city of Khartoum; stretches of the Blue Nile had also been navigated. But any details of the White Nile and its passage south below Khartoum still remained a matter for speculation.

There were, however, various clues. In the first century AD, according to legend, a Greek merchant, Diogenes, claimed that he had travelled inland from the coast near Zanzibar "for a twenty-five days journey and arrived in the vicinity of two great lakes and the snowy range of mountains whence the Nile draws its twin sources."

This story was recorded by Marinus of Tyre and used by the great geographer Ptolemy to produce his famous map which shows the source of the Nile as two lakes fed by a high range of mountains that he called the Mountains of the Moon. For hundreds of years this map was regarded simply as a geographical curiosity until, in 1848, Johann Rebman, a German missionary, reported that while travelling inland in pursuit of suitable converts he had seen a vast snow-covered mountain called Kilimanjaro. In the following year another missionary, Johann Krapf, claimed to have seen a second snow-capped mountain farther to the north. This was the twin-peaked Kere Nyaga (from which the name Kenya is derived) and was believed by the Kikuyu tribe to be the mythical home of their god Ngai.

These reports, reinforced by information brought back by Arab slavers that in the far interior were two great lakes, the Ujiji and the Nyanza, suggested that Ptolemy's map deserved investigation after all. Victorian society in Britain had become obsessed with solving this mystery, which was considered to be "the greatest geographical secret after the discovery of America". In 1865 the Royal Geographical Society recruited two British explorers, Richard Burton and John Hanning Speke, to verify these various findings and also, it was hoped, to discover at last the true source of the Nile. They arrived in Zanzibar by ship and then, some months later, set off on foot westwards from Bagamoyo.

This terminus of the slave trade with its well-worn caravan routes leading into the dark interior was unwittingly to pave the way for European exploration and, ultimately, colonization. All the early explorers were to use Bagamoyo as their starting point, and many years later it was here that Chumah and Susi, Dr Livingstone's faithful companions, were to deliver his desiccated corpse. They had carried it over 1,500 miles for eleven months, wrapped in bark and cloth, from Chitambo in Zambia where Livingstone had died from exhaustion and ill-health.

During the next twenty-five years British explorers solved many of the geographical mysteries of the interior despite the hardship of overland expeditions. The wearying effect of climate, the debilitation resulting from tropical diseases, the constant danger from hostile tribes and wild animals, not to mention the bitterness of their own personal rivalries, failed to weaken their resolve. The lure of glory back in England and the excitement of Africa itself were their reward.

After his first unsuccessful trip with Speke, Burton went on to explore the Delta of the Niger and the Cameroons in West Africa. Speke and his next chosen companion, Capt. James Grant, followed by Samuel Baker and his wife Florence, could claim to be the true discoverers of the sources of the Nile. Dr Livingstone discovered the Victoria Falls and Stanley discovered Dr Livingstone before surveying Lake Tanganyika and the Congo. Although these explorers helped to redraw the map of the interior more accurately, there was obviously still much to be revealed. In the early 1880s a German naturalist, Dr Fischer, and a Scottish explorer, Joseph Thomson, managed separately to cross the territory of the war-like Masai and investigate a part of the Great Rift Valley. Fischer found Lake Naivasha and Thomson was the first European to see the Aberdares, Thomson's Falls and Lake Baringo. Simultaneously another German, Bauman, was exploring the area around Lake Manyara to the south.

In 1887 a Hungarian sportsman, Count Teleki, and his gifted companion, a German artist called Ludwig von Hohnel, reached a vast lake in the north, known to the local tribesmen as Basso Narok. Teleki quickly renamed it Lake Rudolf to honour his sponsor, the Austrian Crown Prince; now it has changed again and is called Lake Turkana. In his diaries Count Teleki recorded their approach to the lake:

> After working our way through plains covered with black streams of lava, and dotted with craters from one of which clouds of smoke rose, we finally stood upon the beach of the lake. The beautiful water stretched away before us, clear as crystal. The men rushed down shouting, to plunge into the lake: but soon returned in bitter disappointment: the water was brackish! what a betrayal!

The knowledge of the position and size of these lakes was important, for when plotted on the map they appeared as connecting links in a chain heading north towards the Red Sea. But it was not until J.W. Gregory, a young Scottish geologist, collected rock samples near Lake Baringo in 1893 that this remarkable geographical feature was truly understood. After analysis of his samples in London, Gregory concluded that the Great Rift Valley, a 6,000-mile fissure in the earth's crust stretching from the Lebanon to Mozambique, was not formed "by removal grain by grain, by rivers or wind, of the rocks which originally occupied them; but by the rock sinking in mass while the adjacent land remained stationary".

The towering walls of rock that form both sides of this great rift are 3,000 million years old, but the interior of the valley is relatively young. It is one of the most spectacular volcanic regions in the world. Steam vents and boiling springs provide visual proof of the turmoil brewing beneath the ground. This feverish activity gives

the landscape a feeling of impermanence—as if it were constantly rearranging itself. The volcanic ash that bears witness to past eruptions is rich in sodium carbonate which has filtered into the lakes, turning many bitter and a few into almost solid deposits of soda.

Strangely enough, these extreme conditions provide one of the most beautiful of wildlife spectacles. The blue-green algae (or red, as it is in Lake Natron) which grow in these soda lakes is a diet on which millions of translucent pink flamingoes thrive as they pick their way through the shallow water like ballerinas on bright enamel legs. Many of the other less saline lakes also support a large indigenous population of birds—pelicans, egrets, herons, storks, cormorants, brilliant kingfishers and the black-and-white fish eagles.

Count Teleki and the other explorers not only reported their geographical discoveries and their detailed descriptions of flora and fauna; they also brought news of conditions and resources in these various regions. Their accounts understandably whetted the appetite of missionaries, naturalists, geographers and manufacturers back in Europe, all of whom were eager to exploit this new market for their own mercenary reasons. Fortunately, the recent development of the railway engine and the steamboat now made access possible.

The revelation of a whole continent ripe for the picking led to what has been called "the scramble for Africa". By 1901 partition was almost complete and most frontiers had been agreed among the foreign powers—even though, as Lord Salisbury admitted to the City of London, "We have been engaged in drawing lines upon maps where no white man's foot has ever trod: we have been giving away mountains and rivers and lakes to each other, only hindered by the small impediment that we never knew exactly where they were."

The French grabbed most of North Africa. The Germans took South-west Africa as well as the Cameroons, Togo and Tanganyika. Italy won Libya, Eritrea and Somalia. Angola and Mozambique remained under Portuguese control, while the Belgians took possession of the vast Congo Basin. Apart from South Africa and the two Rhodesias (now Zimbabwe and Zambia), the British concentrated their "sphere of influence" over the northern part of East Africa (Kenya) and also Uganda, an even greater prize as it gave them control of the upper Nile and thus of Egypt.

To open up this virgin country, it was vital to have a reliable route of communication. It was therefore decided to build a railway from the east coast to a port on the inland sea of Lake Victoria. Thirty-two thousand Indians, or coolies, were imported to lay the track while local tribesmen went in front to clear the bush. The Africans called

this construction "the iron snake" while back home in Britain those who were opposed to the project called it "the lunatic line":

What will it cost no words can express,
What is its object no brain can suppose,
Where will it start from no one can guess,
Where it is going to nobody knows.

Without the railway, however, there would have been no trade, no towns or industries, no coffee or tea plantations. By the time it was completed, meandering 581 miles up country from Mombasa to Kampala, it had cost £5,000,000 and nearly 2,500 men had died from disease or accidents. About 95 miles inland, near Tsavo, two man-eating lions alone killed more than a hundred workers within a couple of months before the chief engineer, J.H. Patterson, managed to corner and shoot them. In his book *The Man-Eaters of Tsavo*, Patterson describes in a matter-of-fact manner how he tracked one of the animals:

> We found it an easy matter to follow the route taken by the lion as he appeared to have stopped several times before beginning his meal. Pools of blood marked these halting-places, when he doubtless indulged in the man-eater's habit of licking the skin off so as to get at the fresh blood.

To offset the huge expenditure of this railway, the British Government was forced to encourage settlers to develop the country, people who were prepared to take the risks of pioneering. They came from all over Europe and from within the empire and its dominions. Until the outbreak of the First World War they continued to arrive, pitching their tents, cutting and burning the bush, turning the soil with ox-drawn ploughs and experimenting with crops and livestock. The use of hired African labour enabled them to start an agricultural and ranching industry often miles from the railway in a country devoid of roads. In *White Man's Country*, Elspeth Huxley describes Lord Delamere's ranch in these early days:

> There was no luxury about Equator Ranch. The grass huts were surrounded by a corrugated iron *boma* into which cattle were driven every night. In the rains the ground was churned into a bog and the buggy often stuck up to its axles in the mud. There were no proper doors or windows to the grass huts, so that at night the cows were liable to poke their heads through the apertures and breathe heavily into the sleeper's face. After a year or so a little wooden hut was built for Lady Delamere.

This first wave of pioneers was brought to an abrupt end by the outbreak of the First World War. Most of these early settlers enlisted in volunteer units such as "Monica's Own" and "Bowker's Horse" who were sent to fight in the East African campaign against the German forces in neighbouring Tanganyika.

Since annexing this area as a protectorate in 1884, the Germans had themselves achieved a considerable amount of development. Railways now crossed the country from the new capital, Dar es Salaam, to Kigoma on Lake Tanganyika and from Moshi in the north to Tanga on the coast, which was soon to become the main centre for producing and exporting sisal. Schools had been introduced, usually run by missionaries, and also a biological and agricultural institute had been established. In the towns, trees were planted and fine churches erected; perhaps the Administrative Headquarters at Bagamoyo, built in 1897, is the best surviving example of German colonial architecture.

Despite fighting a brilliant guerilla campaign in which he defeated and outwitted the superior British forces, the German Commander, General Paul von Lettow-Vorbeck, still had to surrender his troops after the armistice in 1918. Under a League of Nations mandate, the districts of Rwanda and Burundi were given to the Belgians and the rest of the country was ceded to the British.

After the war a fresh start was made throughout East Africa. Many ex-officers, disillusioned by the constrictions of civilian life and flush with capital confidently borrowed from the banks, arrived to try their hand at farming in the colonies. Kenya, in particular, attracted rich, well-bred Europeans keen to enjoy its temperate climate, splendid scenery, lack of servant problems and, of course, the marvellous opportunities for the sportsman and game hunter. Large estates were nurtured, based on cash crops such as cotton, coffee, tea, pineapples and sisal. Fortunes were made and lost. During the 1930s and '40s the notorious antics of a small minority, a self-indulgent upper-class coterie nicknamed the Happy Valley Set, culminated in the unsolved murder of the Earl of Errol. The Second World War and the subsequent black African agitation for democracy and the overthrow of colonial rule put a sober end to this over-romanticized era.

While the white-dominated farming economy in Kenya was booming, the Africans had little to show for their efforts. Jomo Kenyatta, leader of the largest and most influential tribe, the Kikuyu, was convinced that *uhuru* (freedom) could be obtained only by force. In 1952, the year that the Princess Elizabeth, while game viewing from a lodge in the Aberdare forest, learned that she had become Queen of England, the Mau-Mau rebellion erupted. The British declared a state of emergency, and with the

imprisonment of Kenyatta and other black leaders nearly a decade of violence, blood-shed and terror began. Although only thirty-two Europeans were murdered, thousands of Africans were killed and even more were confined to concentration camps before the rebellion was defeated. The British Government, however, had to concede that the time for independence was imminent. Eventually, in Nairobi on 12 December 1963, the Union Jack was pulled down at a midnight ceremony to raptur-ous applause from an exultant black crowd.

Jomo Kenyatta, a middle-aged socialist lecturer and former extra in African jungle films, became the first President of the Republic of Kenya. His success in achieving his political aims was soon to spark off similar results elsewhere in East Africa. Within the next few years Uganda, Tanzania and Somalia followed suit in becoming self-governing black African countries with their own individual ideologies.

A Beginning and the End

The fact that Jomo Kenyatta seemed to have no personal desire for revenge was indeed a measure of the man. Sensibly he encouraged the European community to stay in his country and he maintained British advisers and technicians in his adminis-tration until Africans were qualified to replace them. However, to improve the general standard of living and to combat the obvious problems of poverty, ignorance and disease, Kenyatta repossessed land in the rich farming area of the White Highlands and handed it back to black peasant farmers, thus turning the social wheel full circle. For it was here, near Gilgil and Nakuru, that the Happy Valley set had built their houses, such as the Djinn Palace on the shore of Lake Naivasha. But few now continue to live in that privileged and indolent style.

Primordial Africa remains nearby, unperturbed by any such petty considerations. Within the boundaries and fences of the national parks and game reserves, a concept first proposed by Lord Delamere in 1900, some of the last great concentrations of wild life still graze, obedient to the unchanging rules of nature. Supposedly they are secure from human interference, but the sad truth is that these parks are too large to patrol and the number of wardens too few to halt the increasing depopulation by armed gangs of poachers who supply an international black market with illegal ivory and rhino horn.

Man seems ever determined to destroy his environment, even at his own expense. Unable to live in what we now know to be a vital co-existence with the animals of the natural world, we continue to damage beyond repair the intricate and fragile ecology on which we, ourselves, depend. "This, then, is the tragic paradox of the white man's encroachment," explains Peter Beard in his remarkably evocative book *The End of the Game*:

> The deeper he went into Africa, the faster the life flowed out of it, off the plains and out of the bush and into the cities, vanishing in acres of trophies and hides and carcasses. The coming of the white man, who imposed his steel tracks, his brain, and his will on the great continent, was attended by glory and courage, ennobled by sacrifice, enriched by science, medicine and law. But it marked the beginning of the end in a land where nature herself had always been sovereign: at once sickness and cure, crime and punishment, beginning and end. Not the least of the signs of decay and dying was the gradual, remorseless end of the wild game.

Even, so the vastness of Africa still provides sanctuary for many species that have survived to allow us a vision of life on earth unchanged since the dawn of creation. The lakes of the Great Rift Valley act as staging posts on one of the main migration routes, and in early spring swallows and wheatears in their thousands, as well as storks, cranes, eagles and hawks, ride the thermals. As the hot air rises between the precipitous walls of the rift, they will once again be launched on their way north to another breeding season in eastern Europe and Russia.

This extraordinary landscape has for many thousands of years also supported a complicated pattern of native tribes. In the extreme north, in the Afar triangle of Ethiopia, live the fierce Danakil who still might murder or castrate unwanted strangers. Far to the south are the proud and independent Masai, whose ochre-daubed braves once harassed and attacked the early travellers. Between these two are the tribal lands of the Kikuyu, the Njemps, the Tugen, the Samburu, the Pokot, the Rendille, the Turkana and the Galla. Some of these specialize in hunting or fishing, some are agriculturalists growing subsistence crops, most are semi-nomadic pastoralists herding cattle, camels and goats. But all these tribal families are unique, with their own tradition, language and racial origin. Some are Bantu, others Nilotic, Hamitic or Nilo-Hamitic. In most cases the men are tall and slender, their fine features composed into a natural dignity and beauty. The women are often gaudy with decoration, intricate beadwork and brightly coloured garments, chattering like magpies. Michel Tournier writes in his novel *The Four Wise Men*: "One might have supposed them to be carved in

mahogany, sculptured in obsidian—even stripped of all clothing, a black is always dressed."

Today, unfortunately, even the daunting Danakil and the aristocratic Masai have been forced to accept some of the pressures caused by an ever-encroaching civilization. To quote Karen Blixen, the Masai warriors, bred on a diet of blood and milk, are now

> ...fighters who had been stopped from fighting, a dying lion with his claws clipped, a castrated nation. Their weapons have been taken from them, their big shields even and in the game reserve the lions follow their herds of cattle ... sometimes they may be capable of gratitude, but they can remember and they will bear a grudge. They will bear us all a grudge, which will be wiped out only when the tribe is wiped out itself.

So it is ironic, perhaps, that here in the rich hunting grounds of the Great Rift Valley, where zebra, oryx, hartebeeste, waterbuck and lion all come down through the reed beds to drink on the lake shore, conditions were judged right for the human experiment to begin. In 1972 near Koobi Fora on the north-eastern shore of Lake Turkana, the anthropologist Richard Leakey found a shattered skull which had recognizable humanoid characteristics. This was later dated to be 2.8 million years old. A decade earlier, his celebrated parents, Louis and Mary Leakey, working in the Olduvai gorge in Tanzania, had already unearthed remains that suggest our species may well have emerged there nearly two million years ago. More recently still, in 1979, Mary Leakey discovered some footprints of these early humans under several layers of solidified ash in Laetoli near the Sadiman volcano.

In his latest book, *Songlines*, Bruce Chatwin puts forward his view that

> Up and down the Great Rift Valley, the woodlands were swept away and replaced by open steppe. A wilderness of sand and gravel, patchy grass and thorn bushes with taller trees lingering in the watercourse. Thornscrub was the country into which the brain of the first man expanded: the crown of thorns was not an accidental crown.

Later, when describing the beginnings of mankind, he continues:

> ...wherever men have trodden they have left a trail of song (of which we may, now and then, catch an echo); and ... these trails must reach back in time and space, to an isolated pocket in the African Savannah, where the first man opened

his mouth in defiance of the terrors that surrounded him and shouted the first stanza of the world song, "I AM."

The exact birthplace and date of man's first awakening are still matters for discussion but one fact is certain: Africa, and in particular East Africa, has a narcotic quality that draws the traveller back, subconsciously, for more. It provokes the desire for a deeper, more concentrated understanding of the African rhythm.

The vast open space and the surrounding width of skyline stretch the inner eye, imperceptibly lightening the soul and easing the burden of twentieth-century man's pompous self-regard.

The volcanic wilderness of Lake Turkana, the prairie grasslands of the Serengeti, the green bowl of the Ngorongoro crater and the misted moorlands high up in the Aberdares, are all important and welcome reminders of what this earth was like before the plough. Modern Africa has preserved within itself places where natural magic still exists, and where the wonders of our industrial and technological revolutions are made null and void and meaningless.

To be able to capture even a hint of this spirit of place on film demands more than just professional skill, or simply being clever or lucky enough to be in the right place at the right time; it requires an ability to receive and transmit images that are much more than mere visual facts.

In these particular photographs, which record a personal journey, Tim Beddow succeeds in communicating his vision of landscape and architecture and his awareness of a simple yet exotic African experience. Whether it is a portrait of three Samburu women posing on their way to market, or geometric rows of coffee under a sea-blue avenue of jacarandas, the peeling fretwork façade of an old dispensary in Zanzibar, or a basic game of roulette played on the side of the road, his relaxed yet pertinent style underlines and illuminates these chosen images. His photographs are also a powerful inspiration that persuasively advocates the intangible rewards of travel. As an old Moorish proverb most succinctly puts it:

"He who does not travel, does not know the value of men."

21

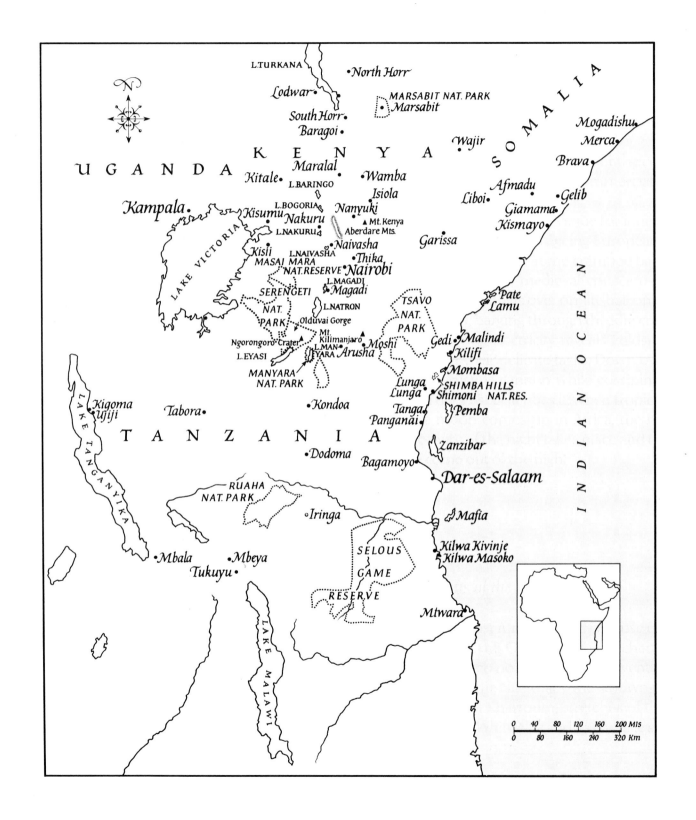

THE PLATES

1 *"Mashua" fishing dhows returning to Zanzibar. They have barely changed since the 7th century when they were used by the early Arab navigators.*

2 A Zanzibari fishing in front of the building where the notorious slaver Tippu Tip once stored slaves.

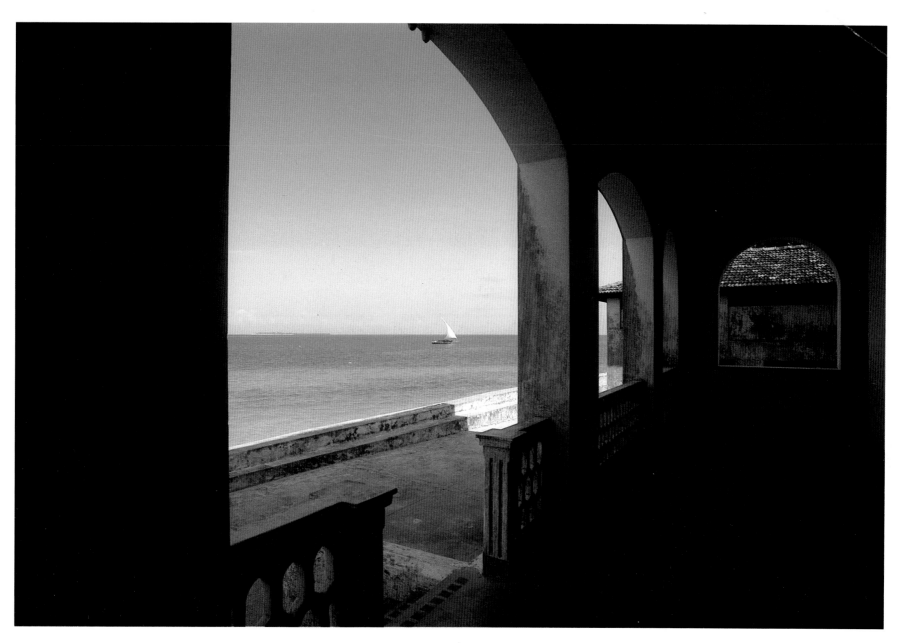

3　On the waterfront, Zanzibar. Some of these buildings are still occupied by foreign nations as consulates.

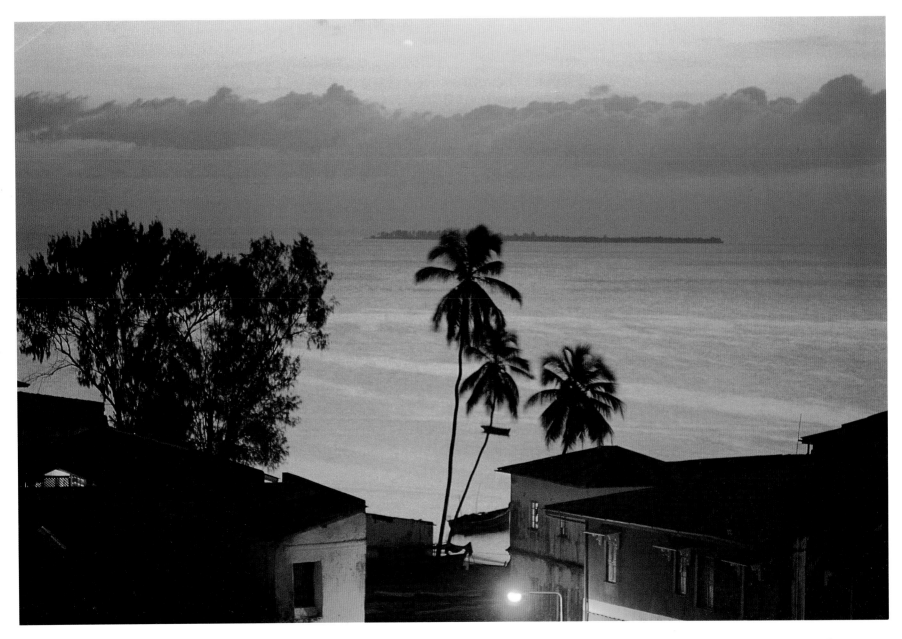

4 *Twilight in Zanzibar, with Prison Island—formerly a place of detention for recalcitrant slaves—in the distance.*

5 *Many houses have decayed in Zanzibar but some effort is being made at conservation.*

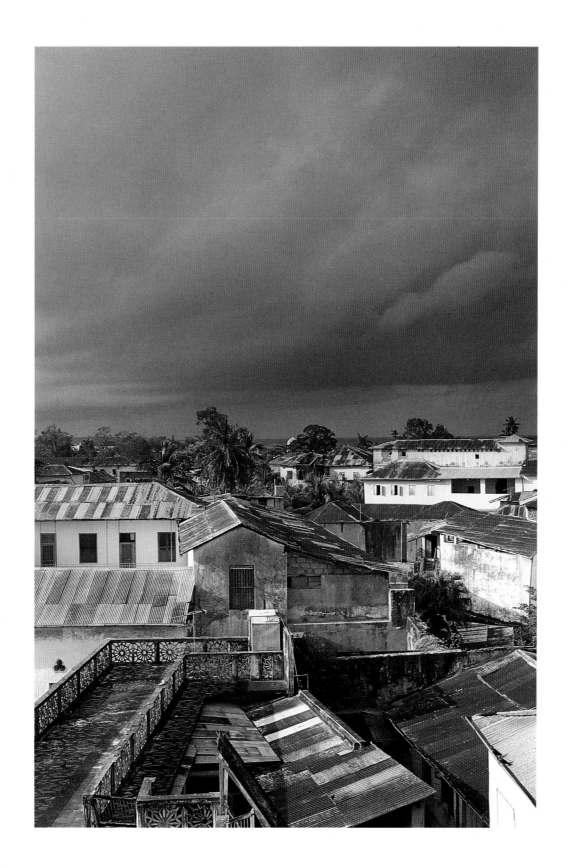

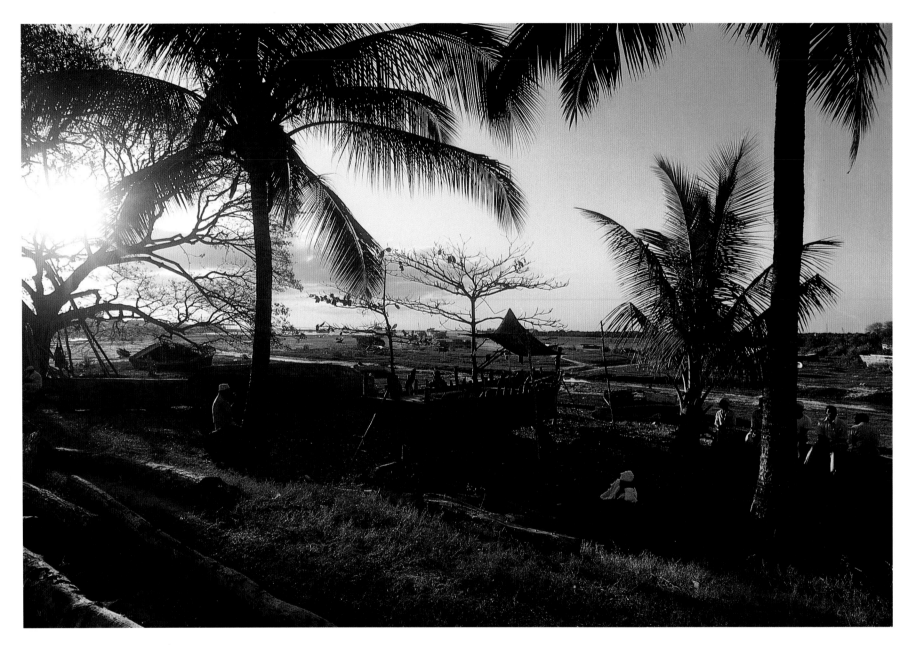

6 *Boat builders, evening, Zanzibar.*

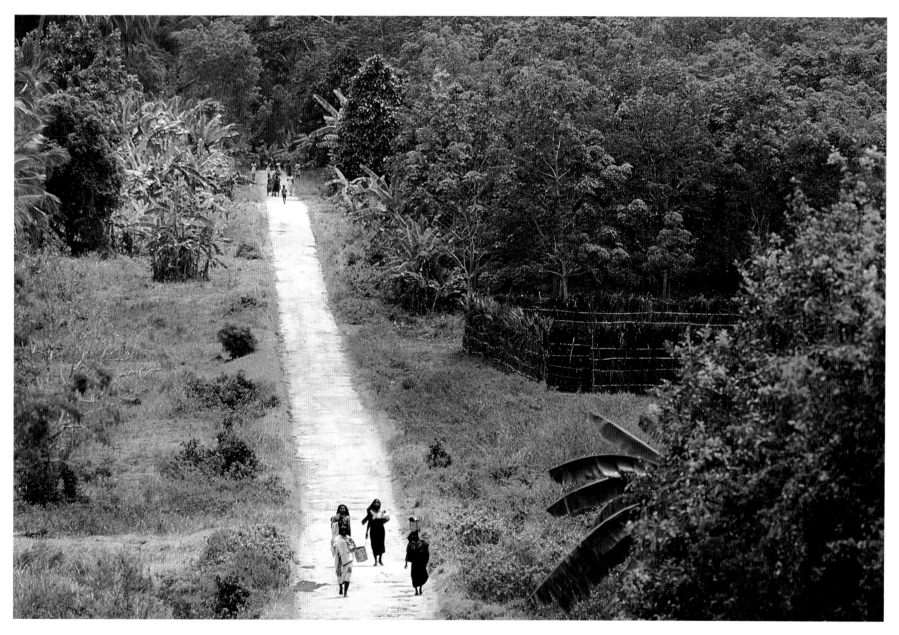

7 *Sometimes called the Spice Isle, Zanzibar's produce includes cloves, peppers, cinnamon, betel nut, cacao, jackfruit, star-fruit and custard apples.*

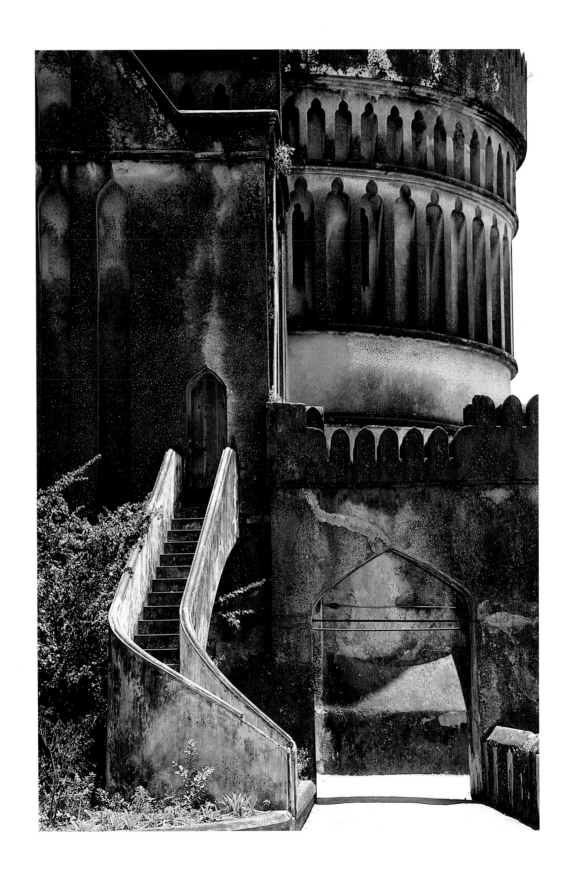

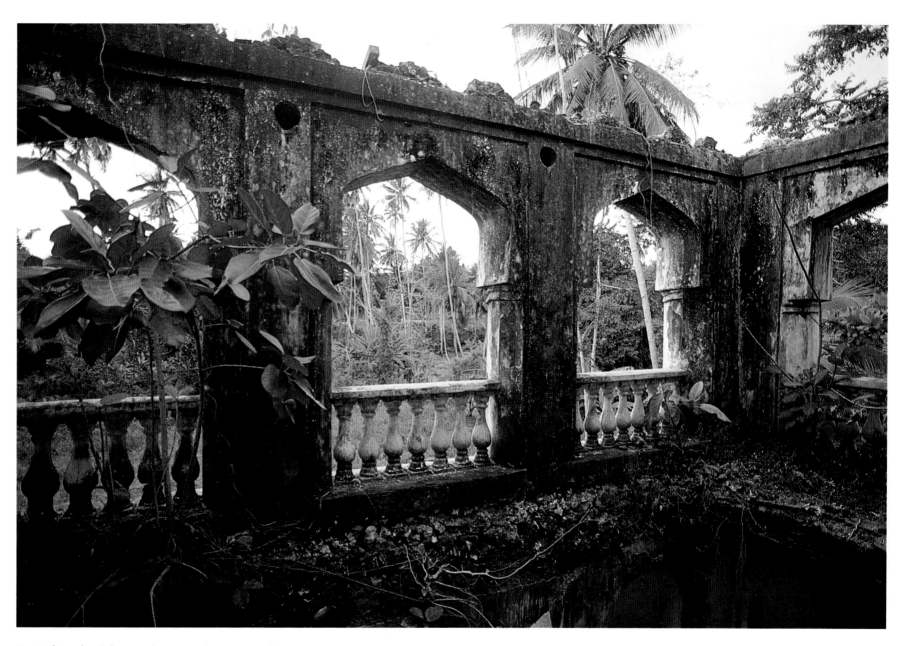

9 *Arab merchant's house in decay, Zanzibar.*

8 (OPPOSITE) *The Cathedral Church of Christ, Zanzibar.*

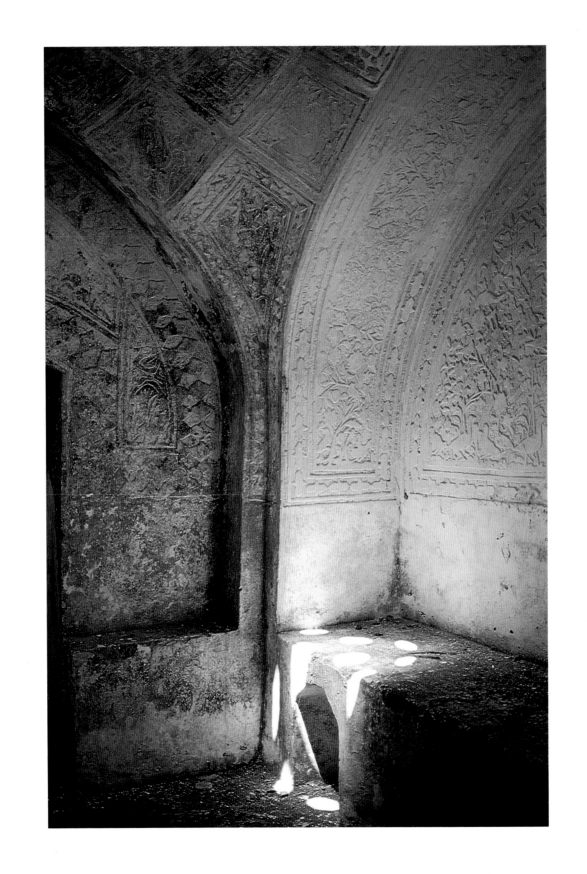

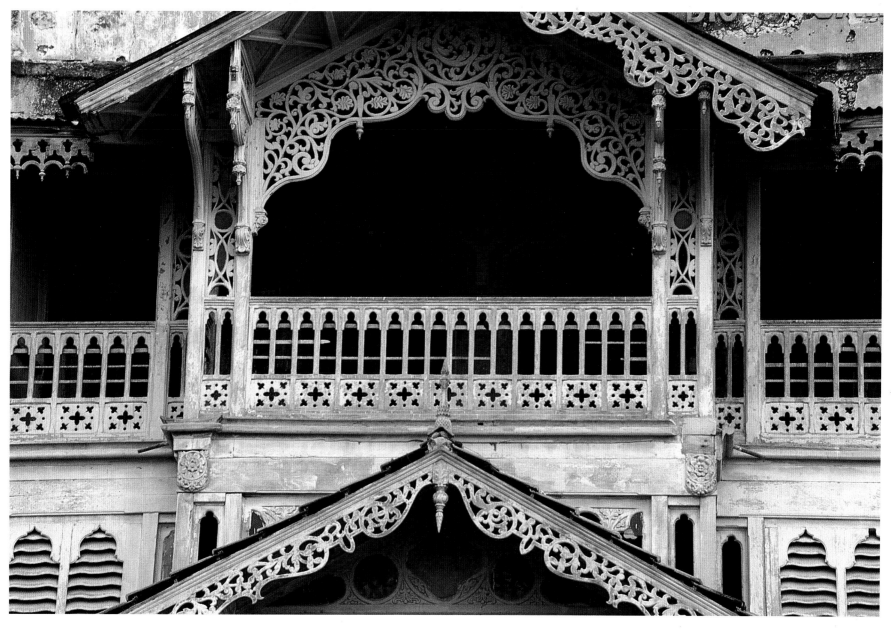

11 Masor Mohammed's Dispensary, Zanzibar. Begun in Queen Victoria's Jubilee Year, it
was intended to be a hospital but was eventually divided up into tenements.

10 (OPPOSITE) The Persian Baths in Zanzibar were built by Sultan Seyyid Said in the mid
19th-century for his Persian wife Princess Shenzad.

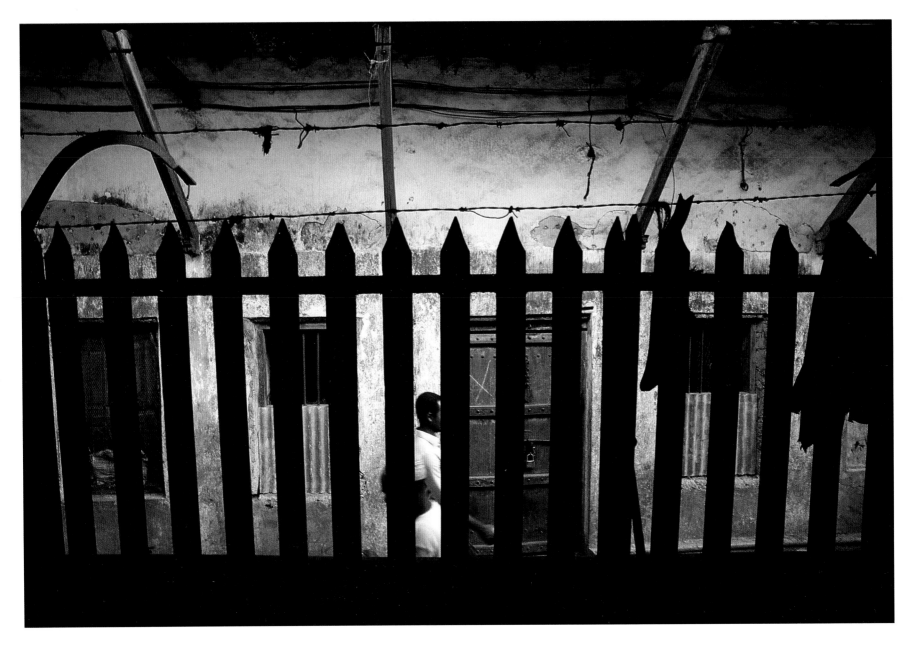

12 *Street scene, Zanzibar.*

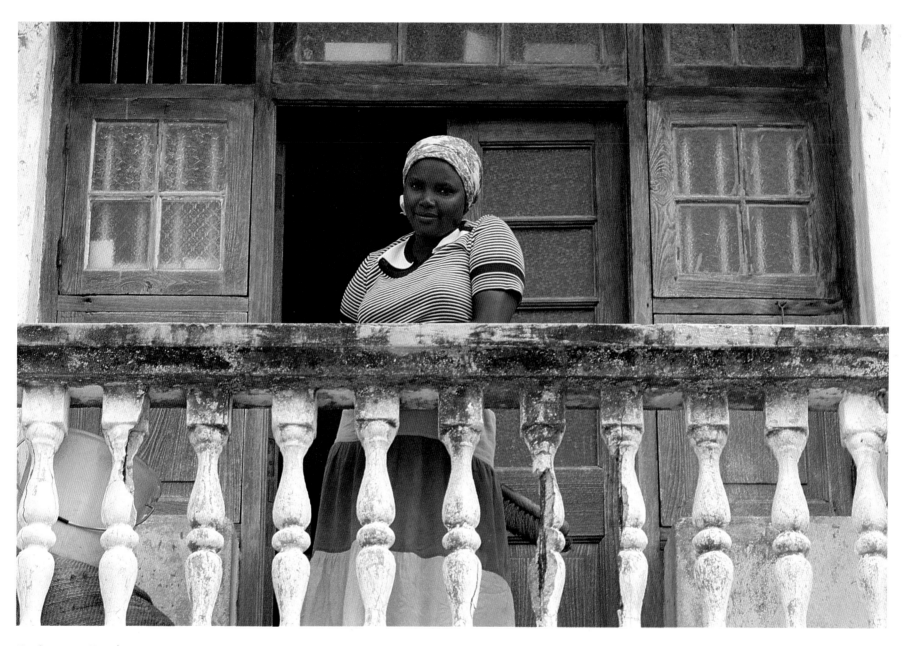

13 *Street scene, Zanzibar.*

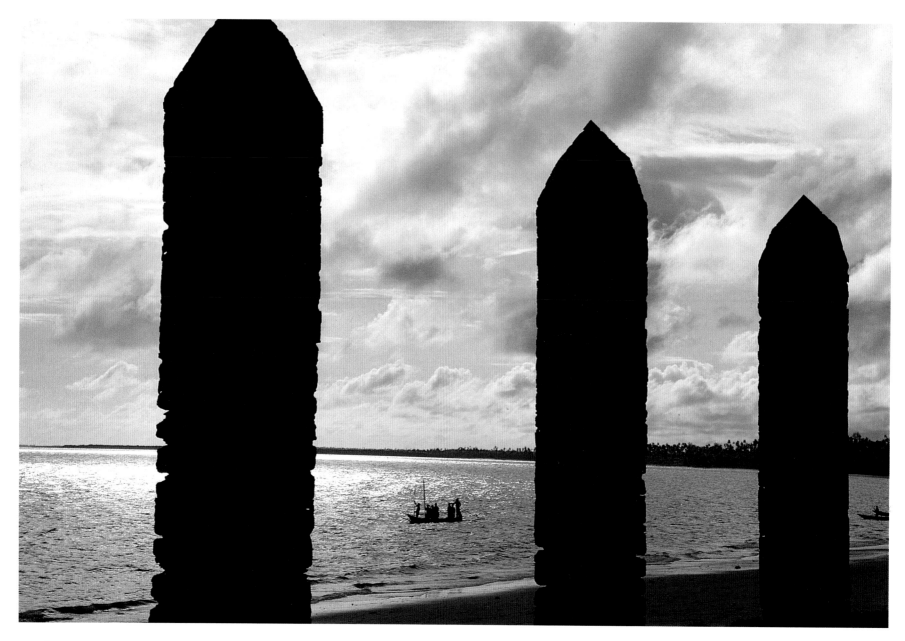

14 *The Customs House, Bagamoyo. Bagamoyo means "lay down the burden of your heart".*

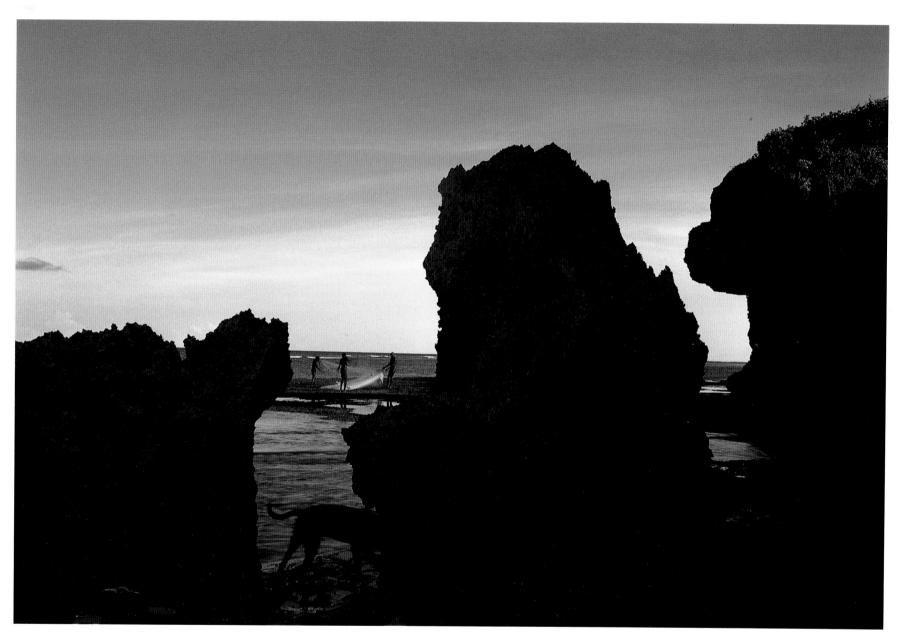

15 Unravelling nets. Although this is named "the Coral Coast", much underwater life
suffers because tourists disturb the fish and steal the coral.

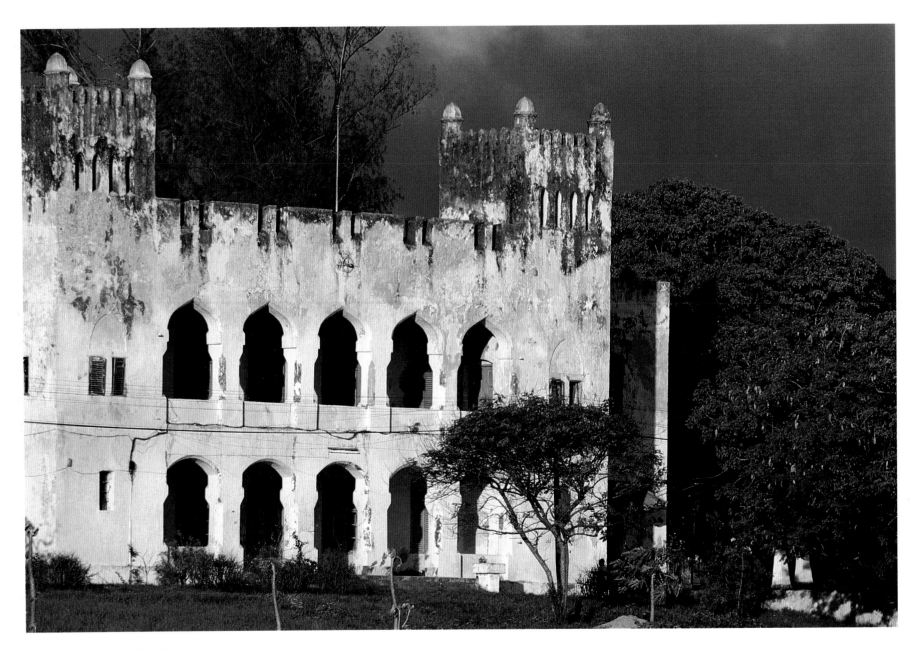

16 *German colonial building, Bagamoyo.*

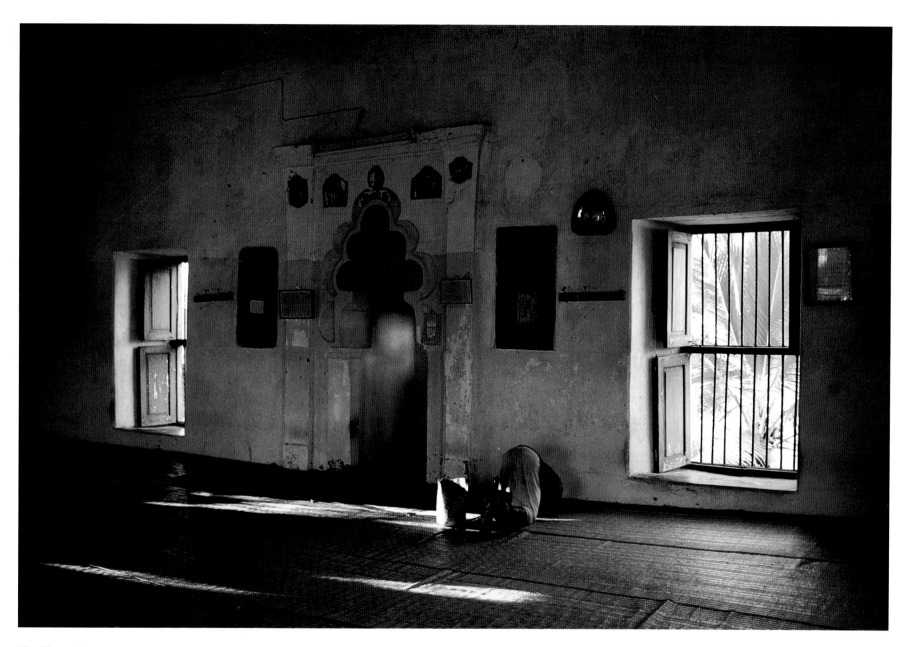

17 *Mosque, Bagamoyo.*

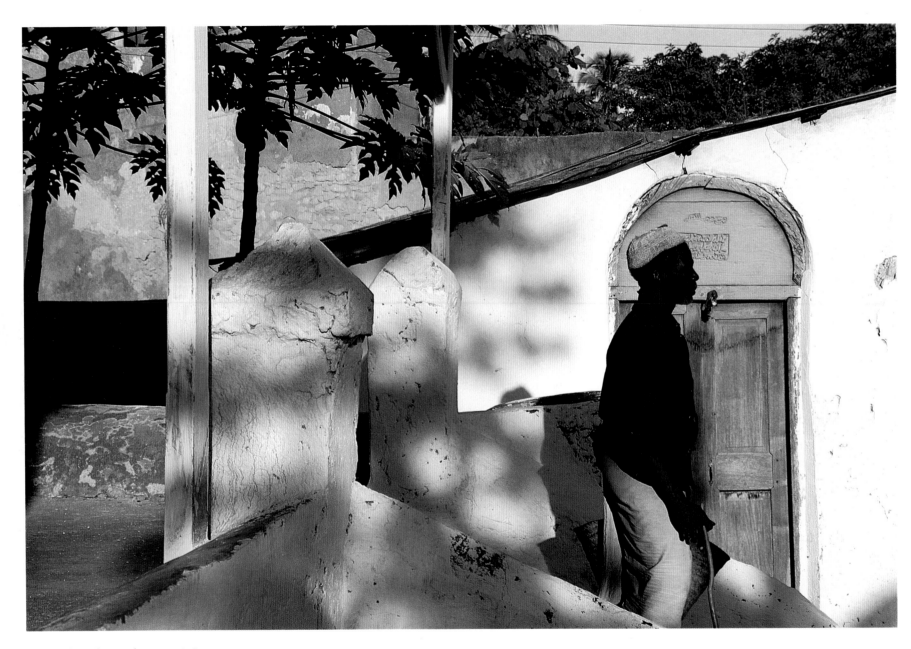

18 Blind man leaving the mosque in Bagamoyo.

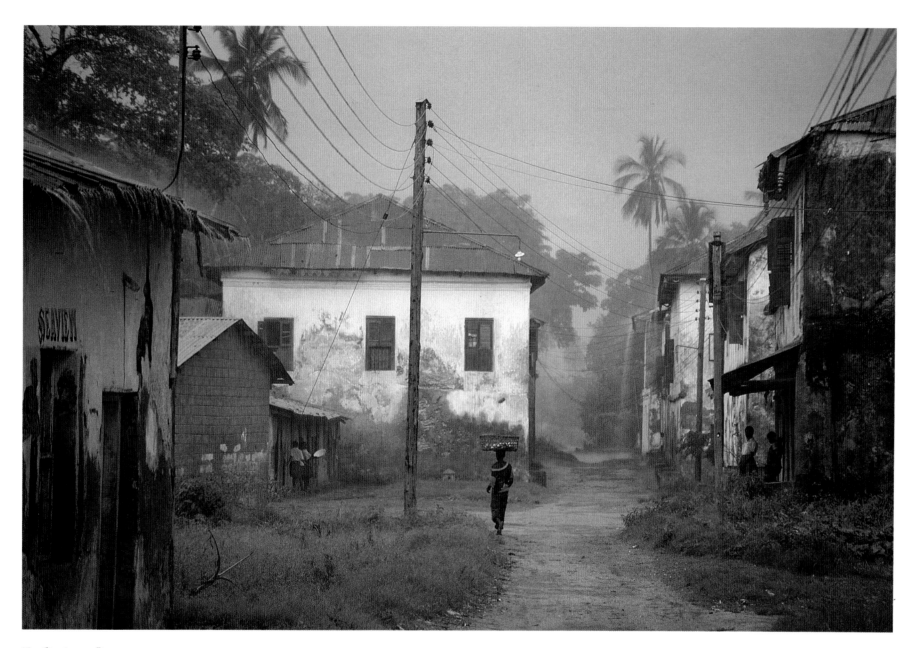

19 *Street scene, Bagamoyo.*

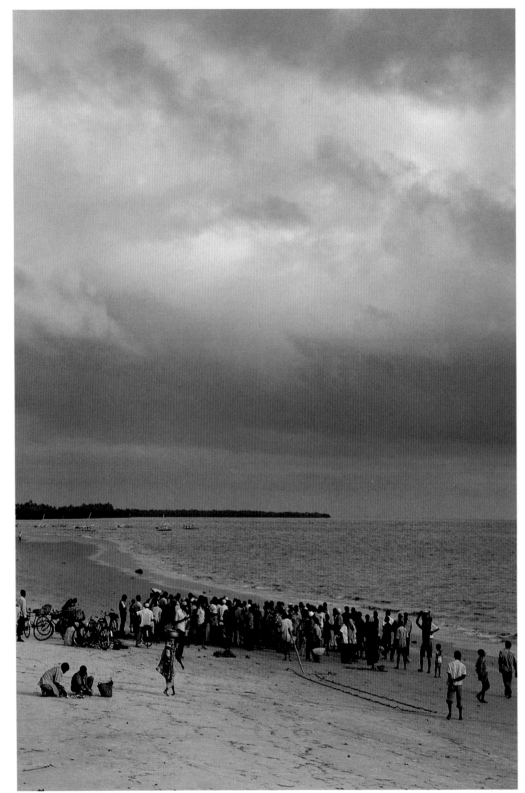

20　At Bagamoyo, the fish market takes place on the beach, with people bicycling from inland villages to buy food.

21　(OPPOSITE) Wrenching a boat from the sand, Bagamoyo.

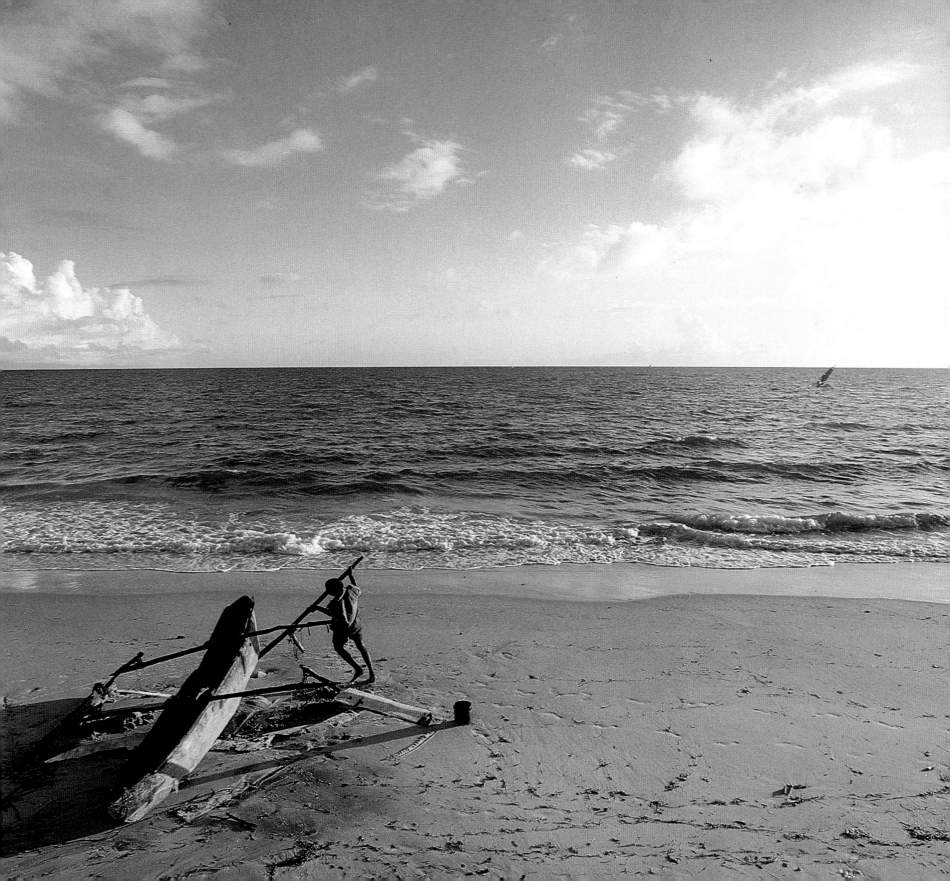

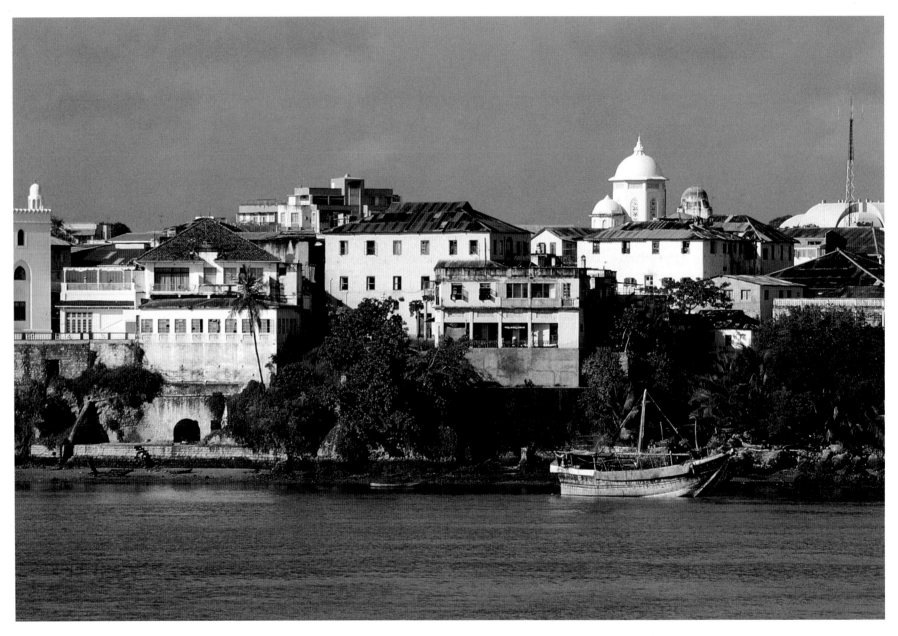

22 *Old town, Mombasa. Dhows in their hundreds once moored here while changing cargoes, but this trade has virtually disappeared.*

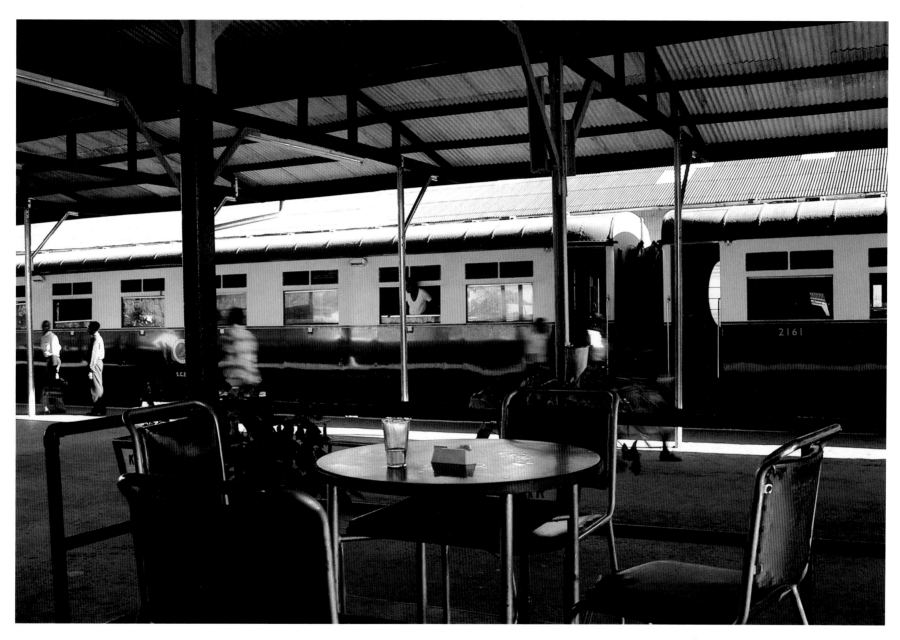

23 Railway station, Mombasa. The Indian coolies who laid the track were allowed to
remain in Kenya if they forfeited their return passages. Many did.

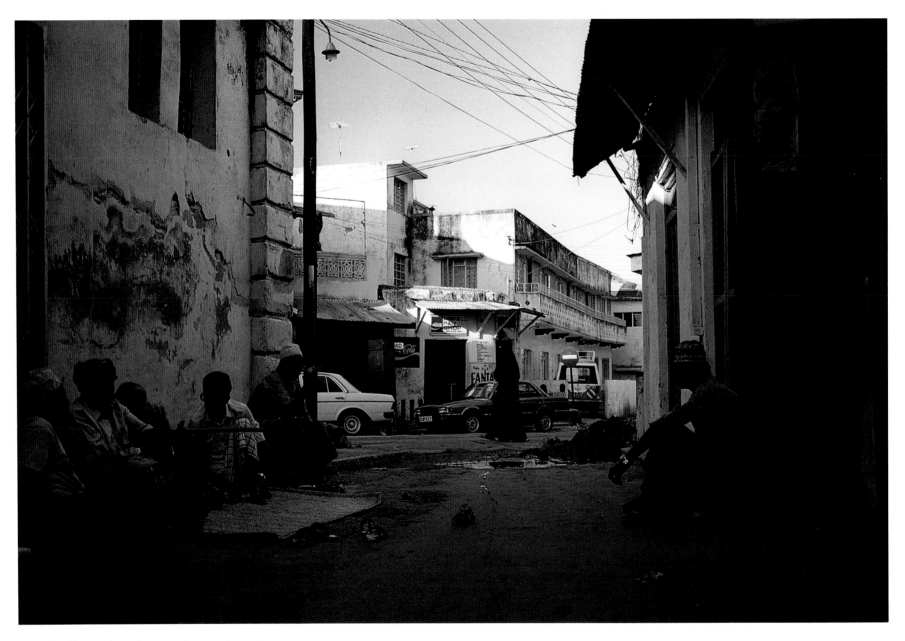

24 *The old town of Mombasa is predominantly Moslem.*

25 (OPPOSITE) *Many come to Mombasa in seedy pursuit of this café's innocent name.*

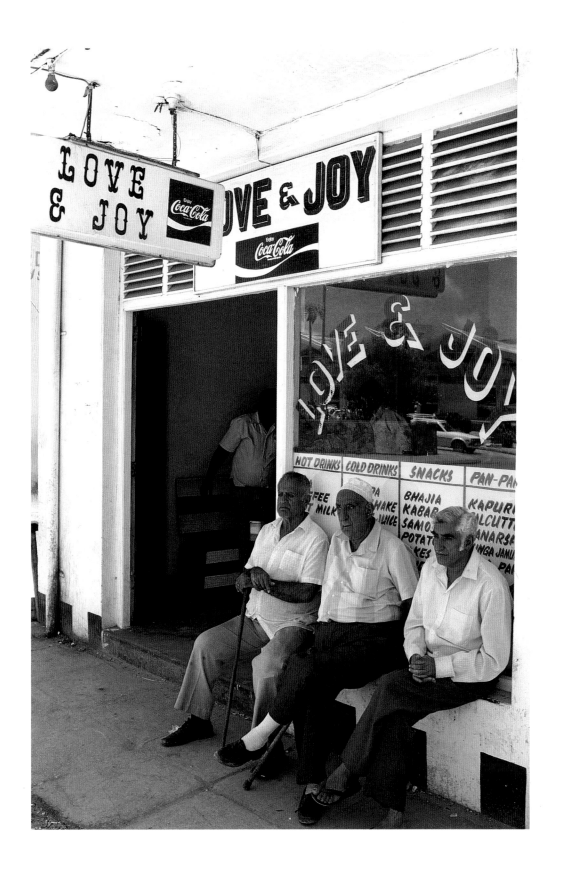

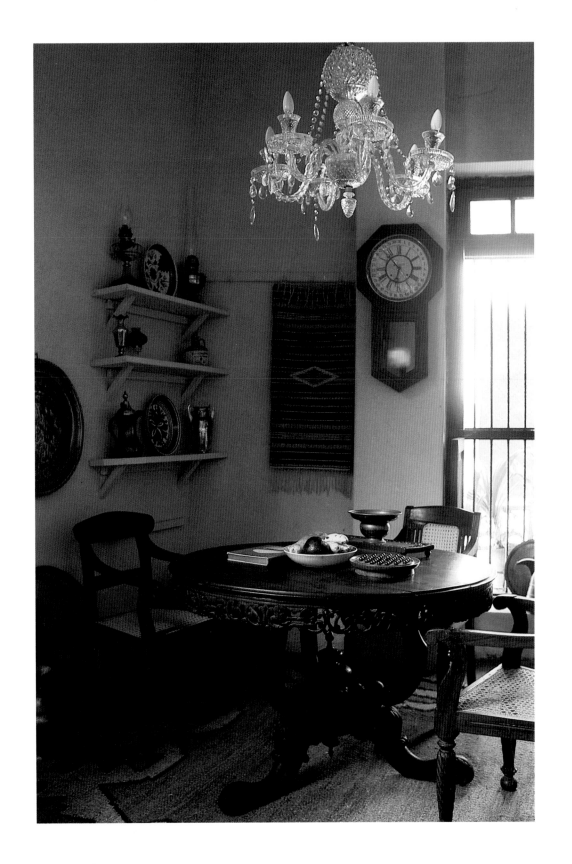

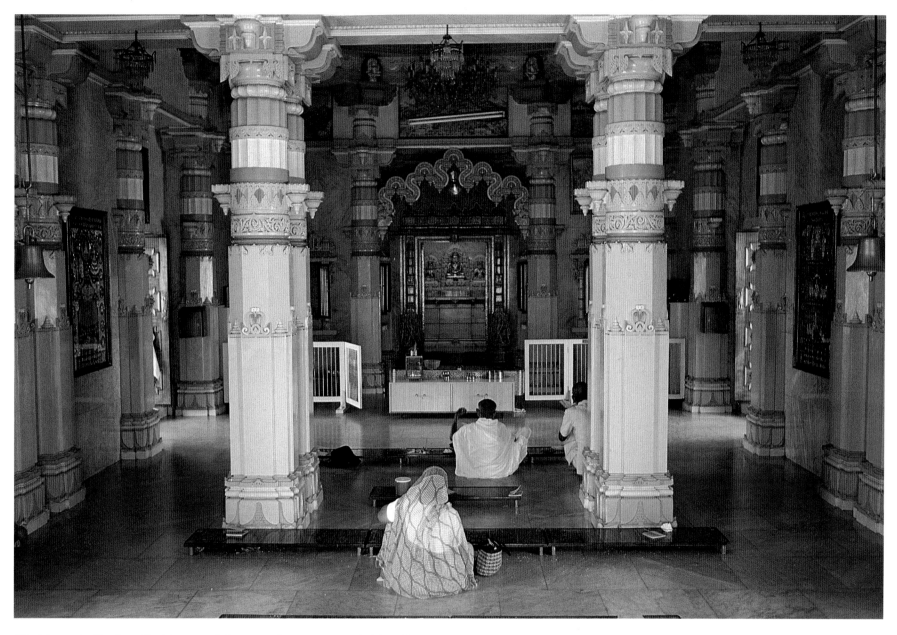

27 Jain temple, Mombasa. The Jains are a religious sect with a strict reverence for life in all its forms.

26 (OPPOSITE) Old town, Mombasa. The clock in this dining-room is 19th-century American. Many like this were traded for cloves, ivory and vanilla.

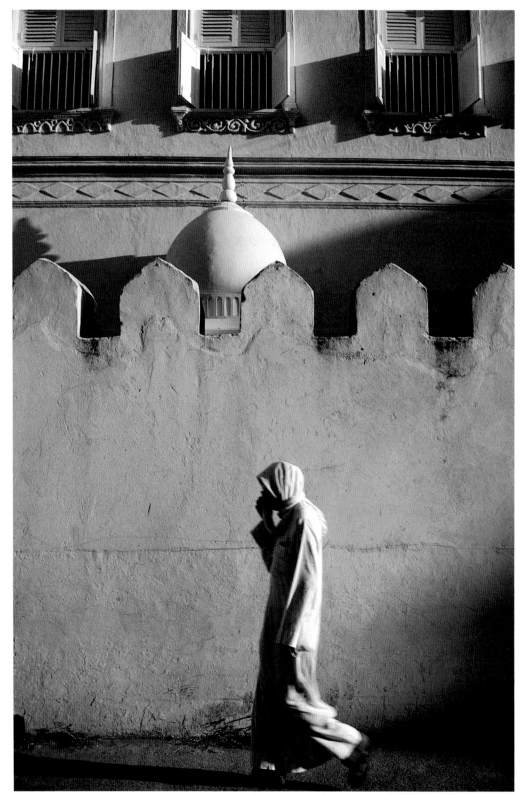

28
Old town, Mombasa, evening scene.

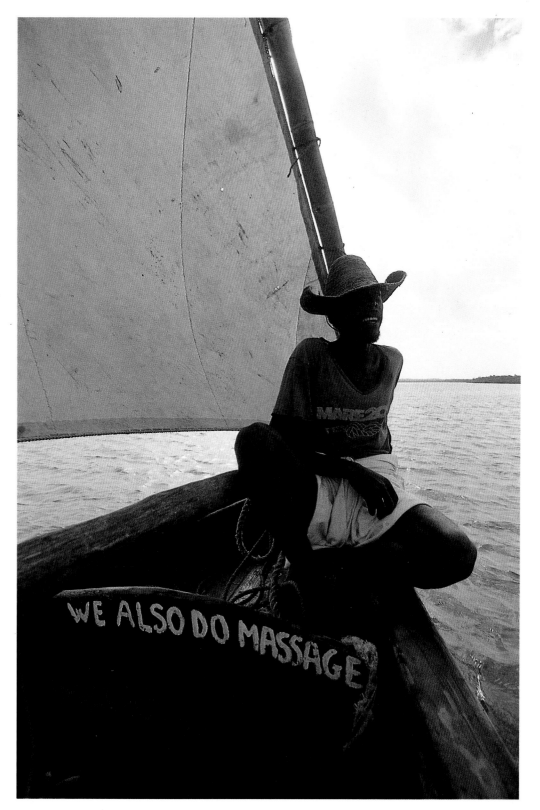

29

Lamu boatman and masseur.

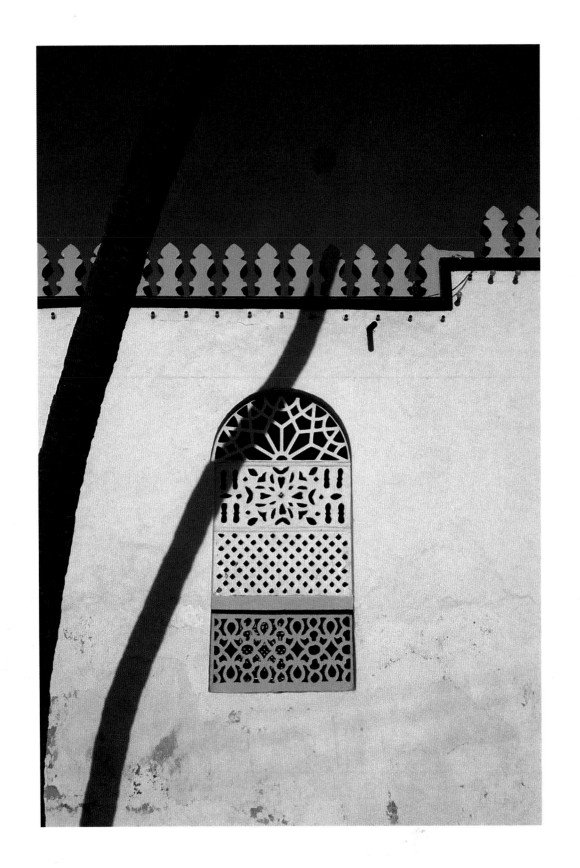

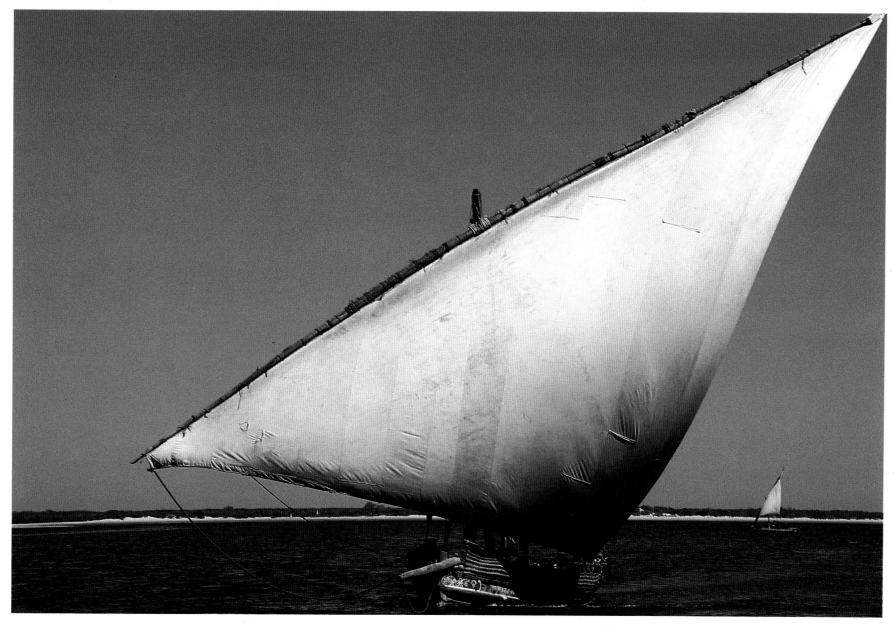

31 *Because there are virtually no cars, transport in Lamu is predominantly by boat. There is
a long tradition of boat-building in the region, and various sizes and rigs have different
names.*

30 (OPPOSITE) *The Riyadha mosque in Lamu still provides the function of a "caravanserai"
where pilgrims can sleep overnight and obtain food.*

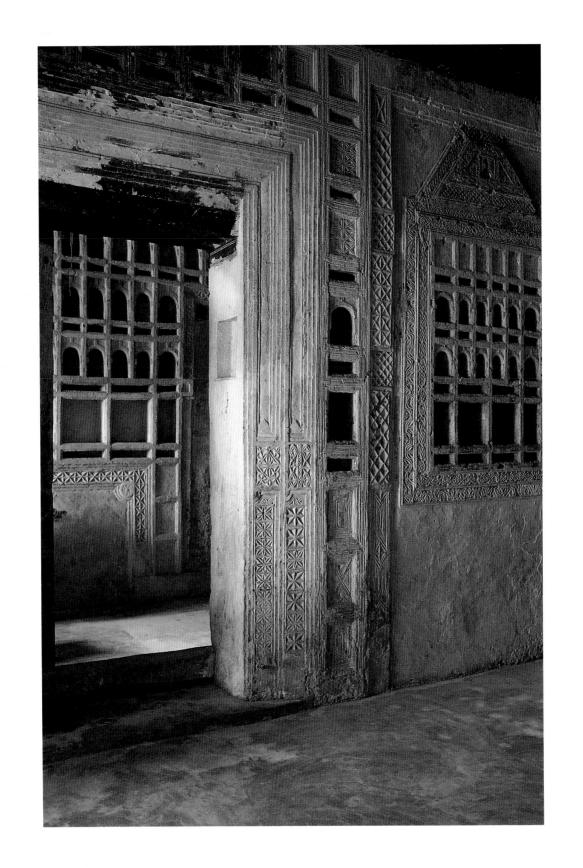

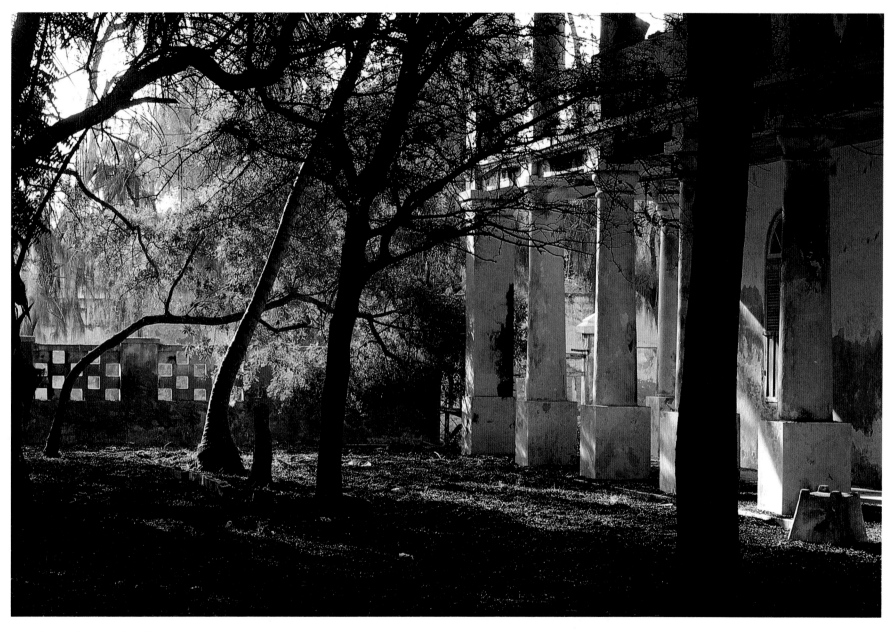

33 *The ruined Italian colonial building in Kisimayo, Somalia.*

32 (OPPOSITE) *Swahili house, Lamu. The intricate plasterwork is for decorative effect. Thick walls keep the interior cool.*

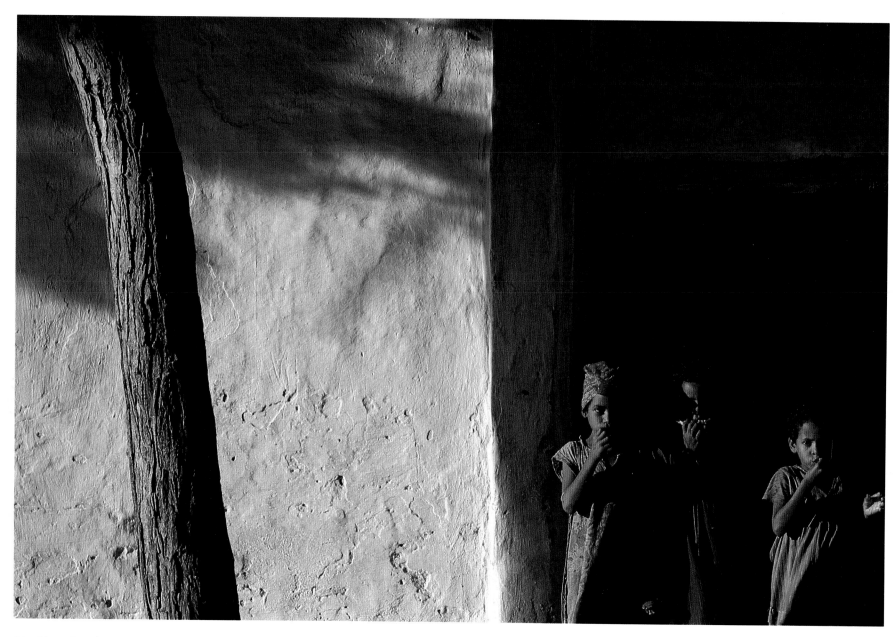

34 *Merca, Somalia.*

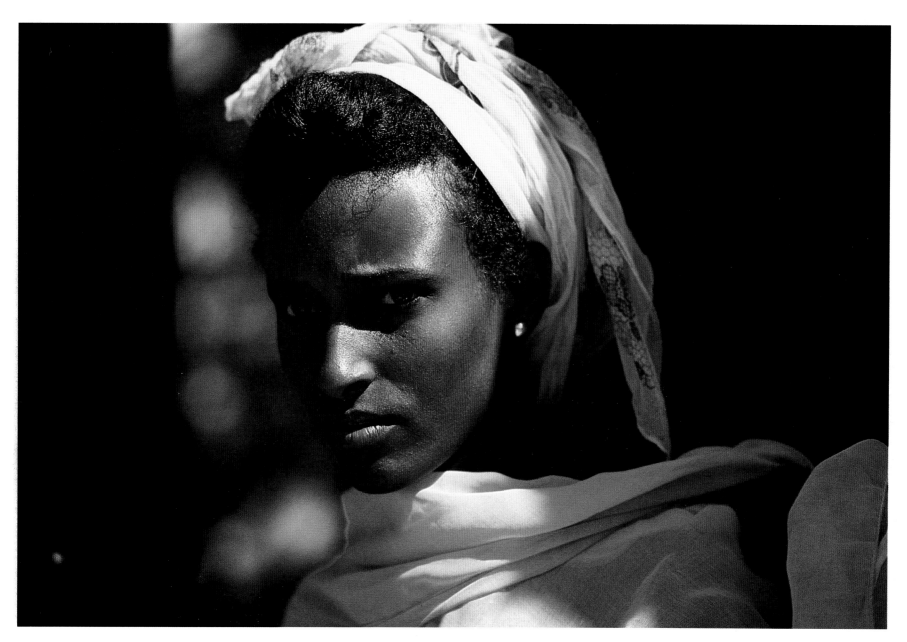

35 *A tall girl of the Darod race in Mogadishu, Somalia.*

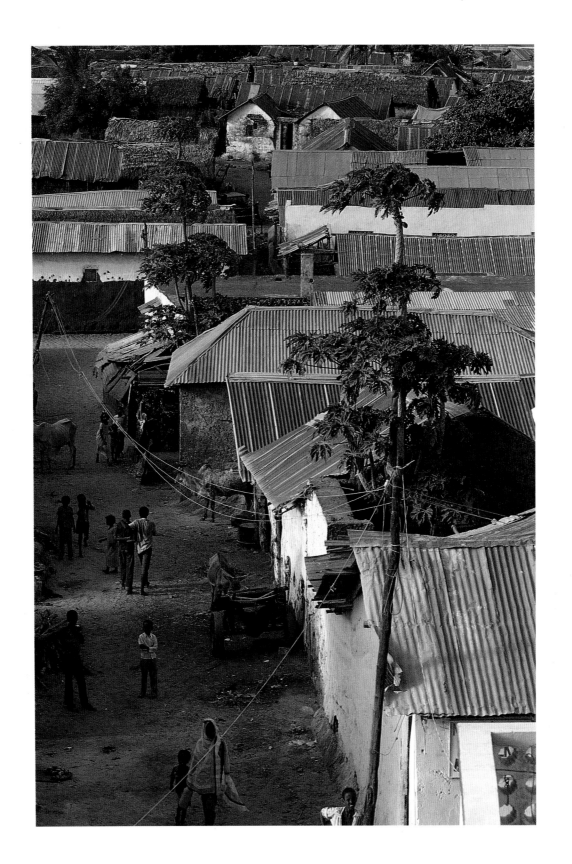

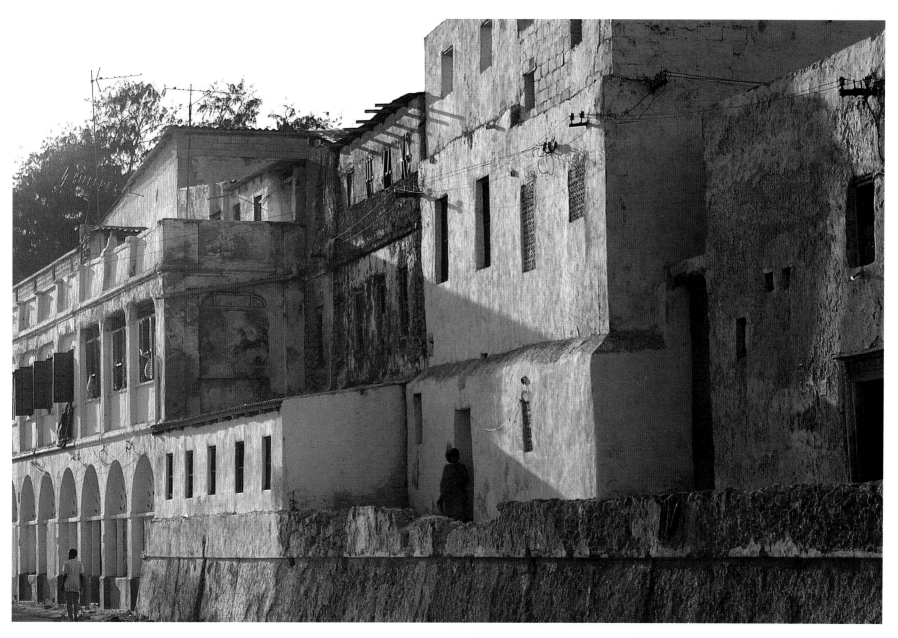

37 Ibn Battuta, the Moroccan traveller, described Mogadishu in the 14th century as "endless in size, where 200 camels were slaughtered daily to provide for the population".

36 (OPPOSITE) Kisimayo, Somalia. Northwards from here the coast becomes arid and lined with sand dunes.

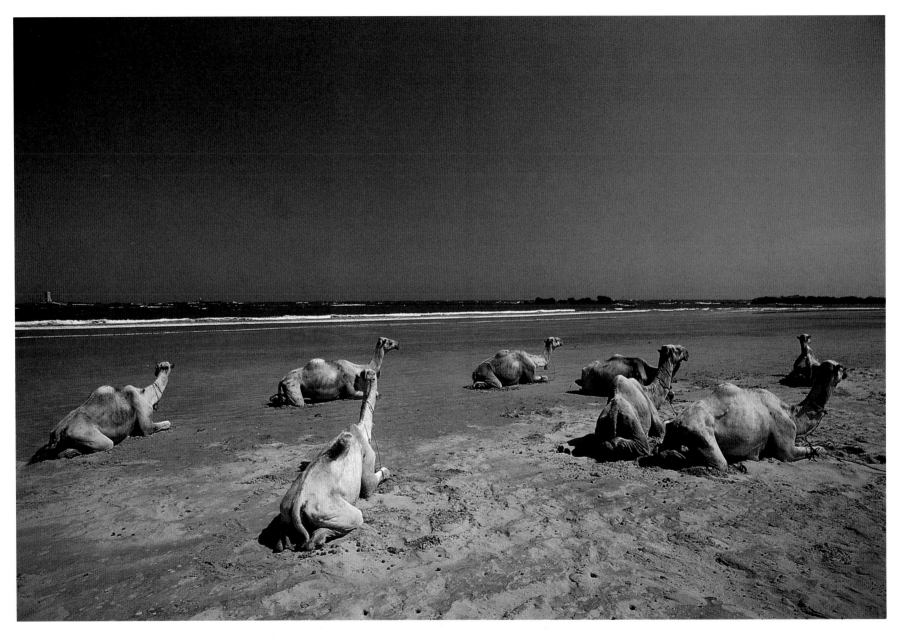

38 Brava, Somalia. Despite having 3,000 km of coastline, Somalis have never liked fish or had a fishing industry. They are being encouraged to exploit this asset.

39 (OPPOSITE) Mosque, Merca.

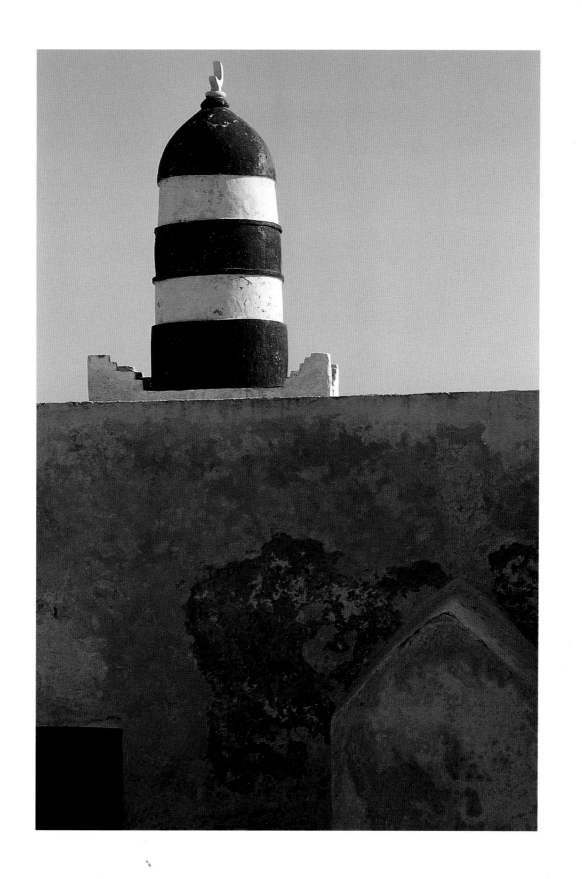

40 Lake Turkana, in Kenya, was once connected to the White Nile and still contains the
Nile perch, fished by the local tribes.

41 Rift Valley, Kenya.

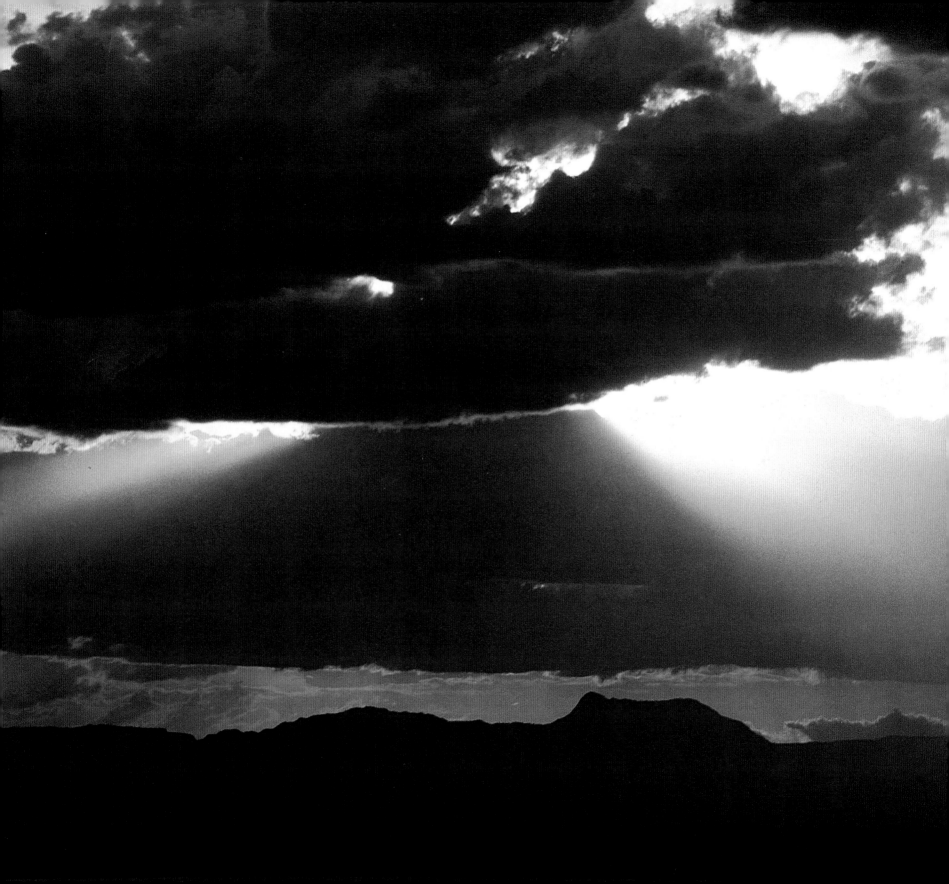

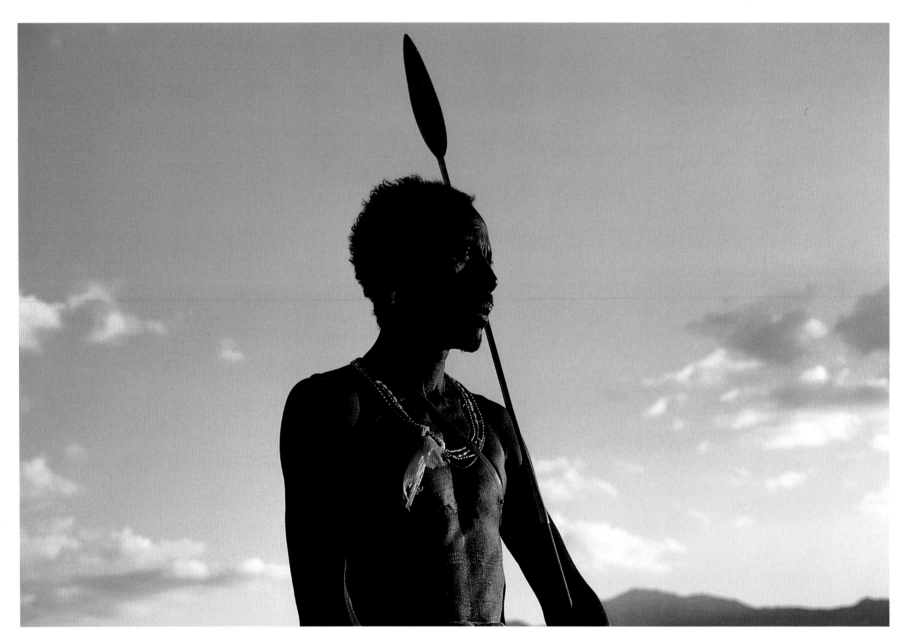

42 Samburu, Ndoto mountains, Kenya. The Samburu, like their Masai cousins to the
south, have a pastoral economy but they do not have the warring reputation of the Masai.

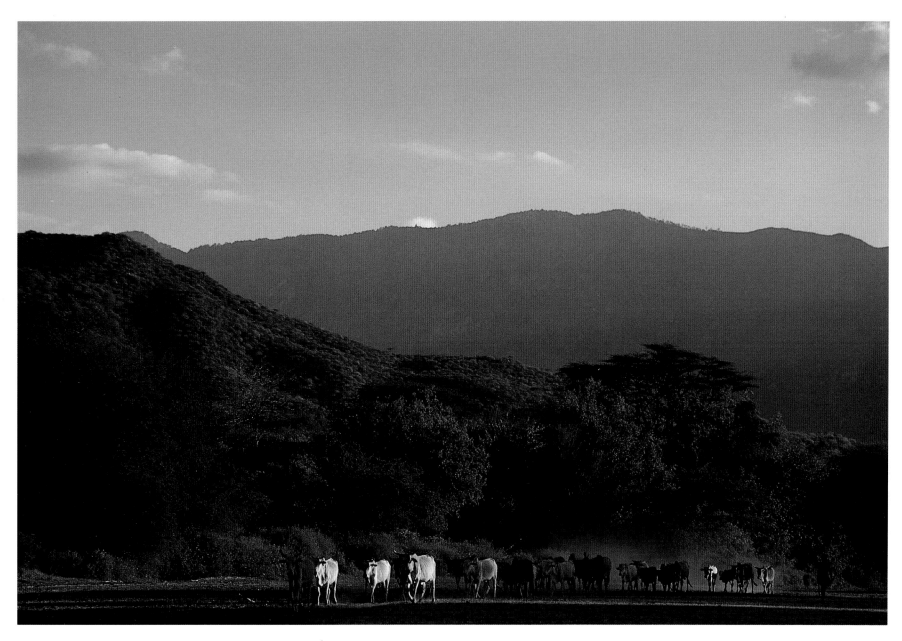

43 *Ndoto mountains, Kenya. The cattle will be put into a* boma *for safety overnight.*

44 (OVERLEAF) *Dramatic section of the Great Rift Valley, Kenya.*

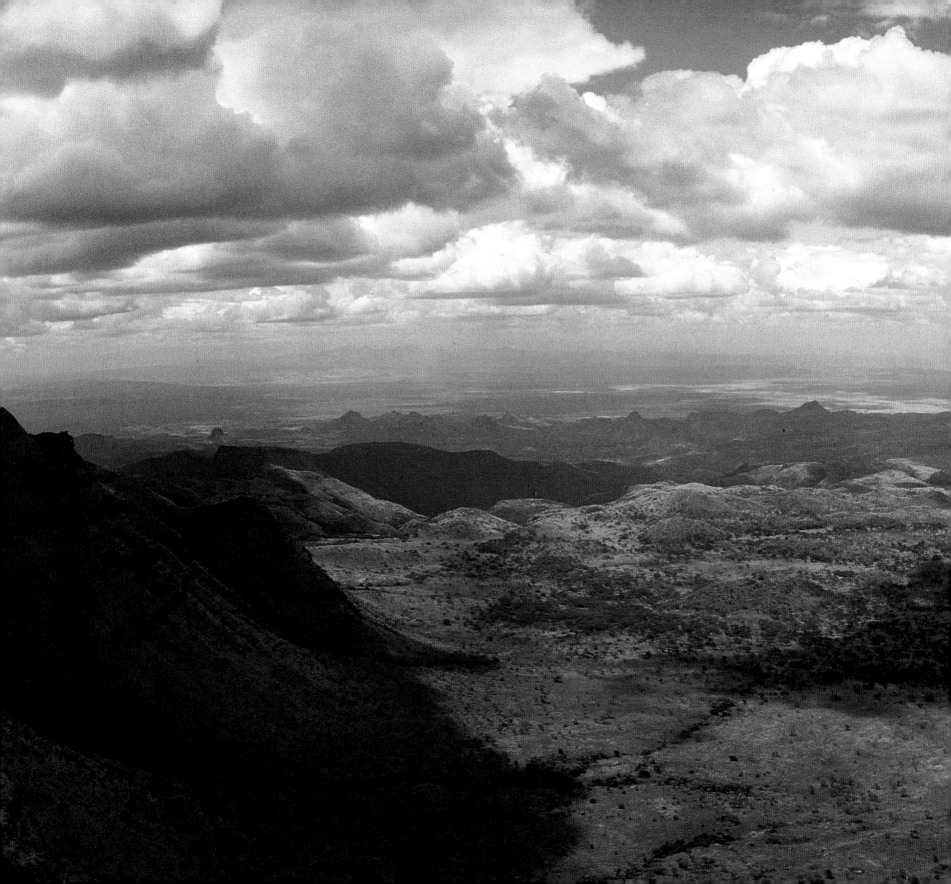

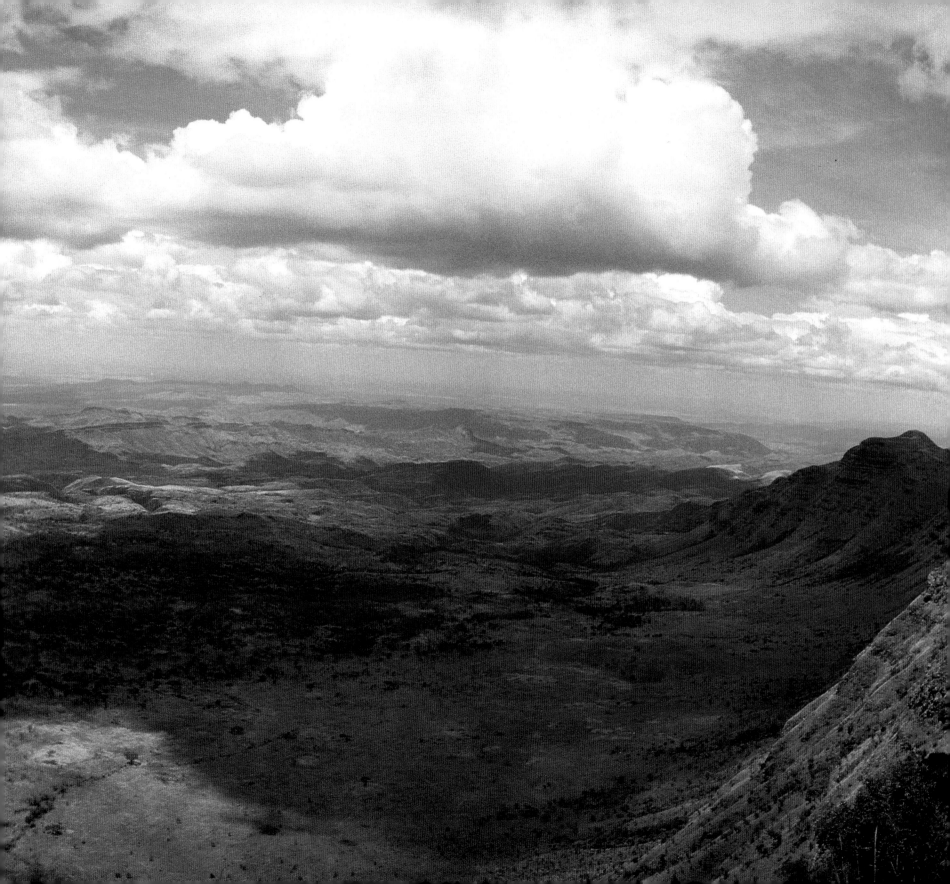

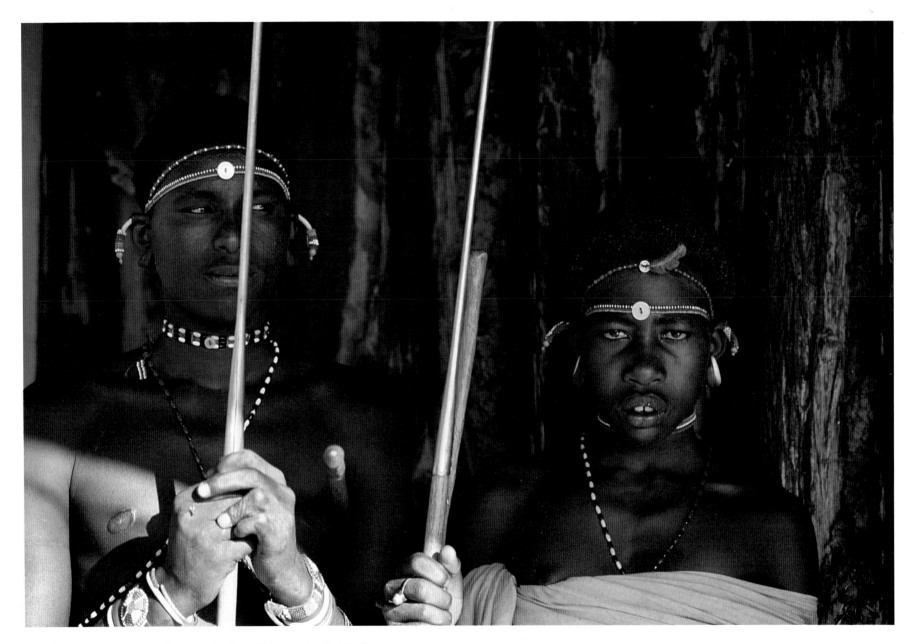

45 *The Samburu are notoriously vain and will spend hours on their bodily adornment.*

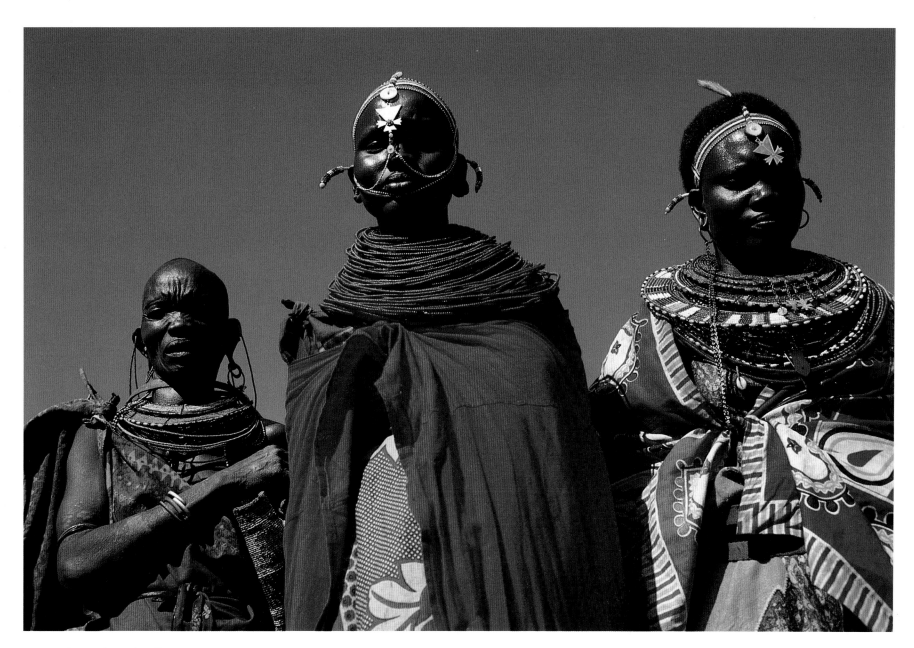

46 *Samburu girls, northern Kenya.*

47 *Rambling settler's house, upcountry Kenya.*

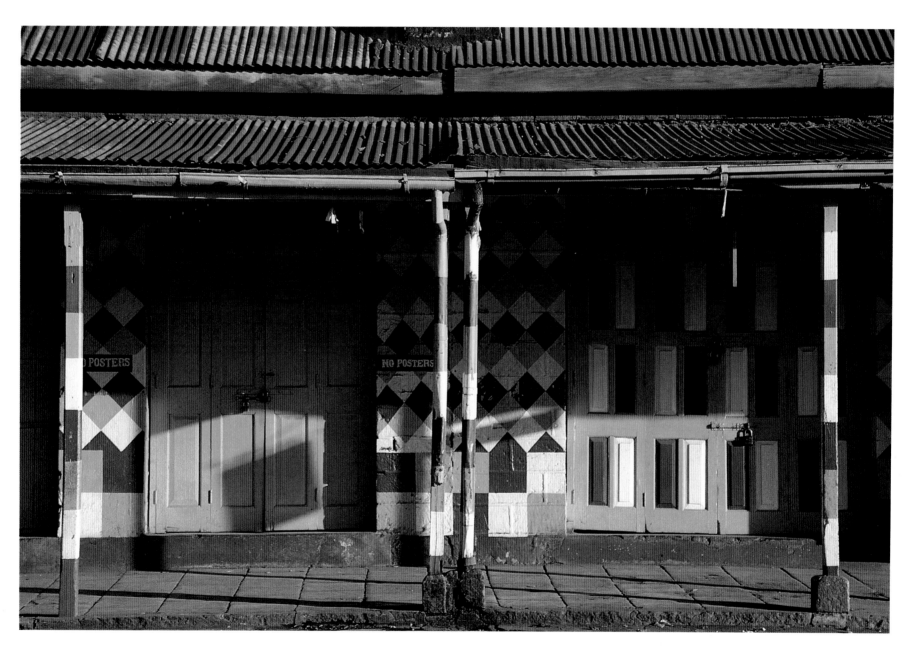

48 Nakuru, the main town for upcountry farmers in Kenya, is best known for its lake and
vast flamingo population.

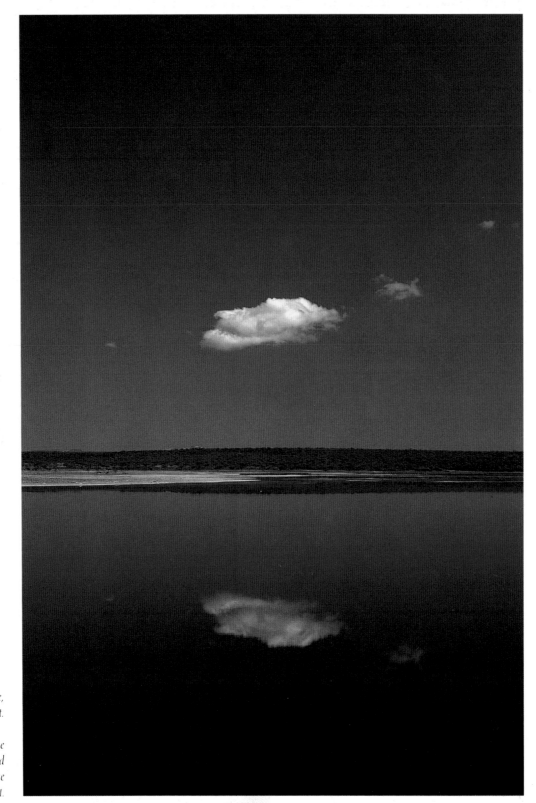

49 Lake Magadi, a soda lake,
 blisters with the heat.

50 (OPPOSITE) Flamingoes feed on algae
 produced in the soda-saturated
 water by chemical and intense
 sunlight.

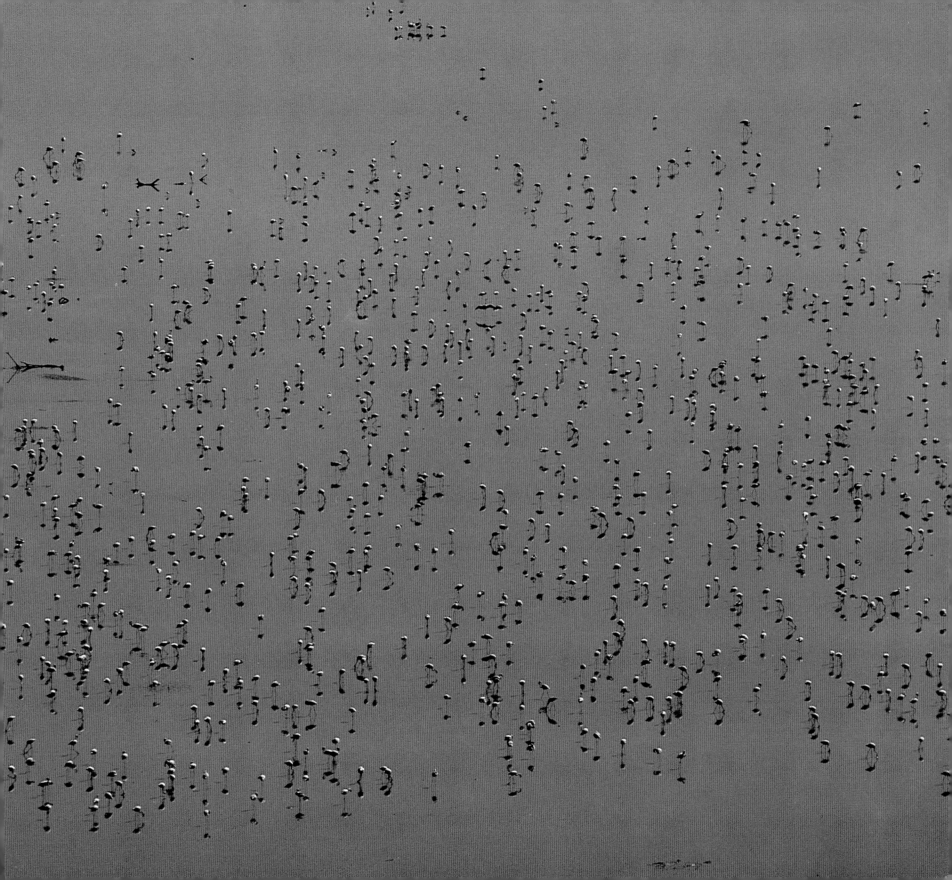

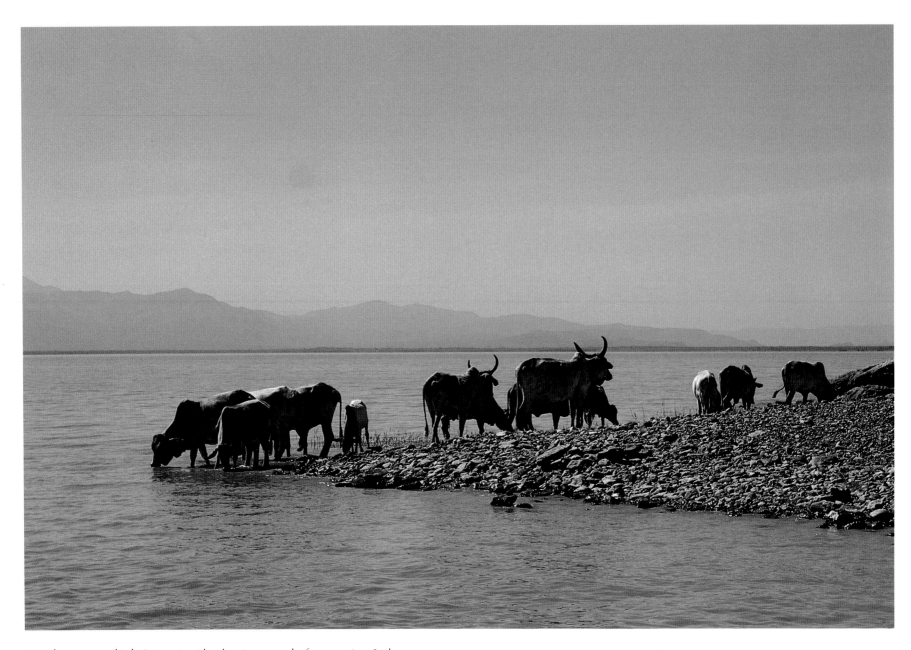

51 *The area around Lake Baringo is arid and a prime example of over-grazing. Cattle are transported to small islands on the lake to find what fodder they can.*

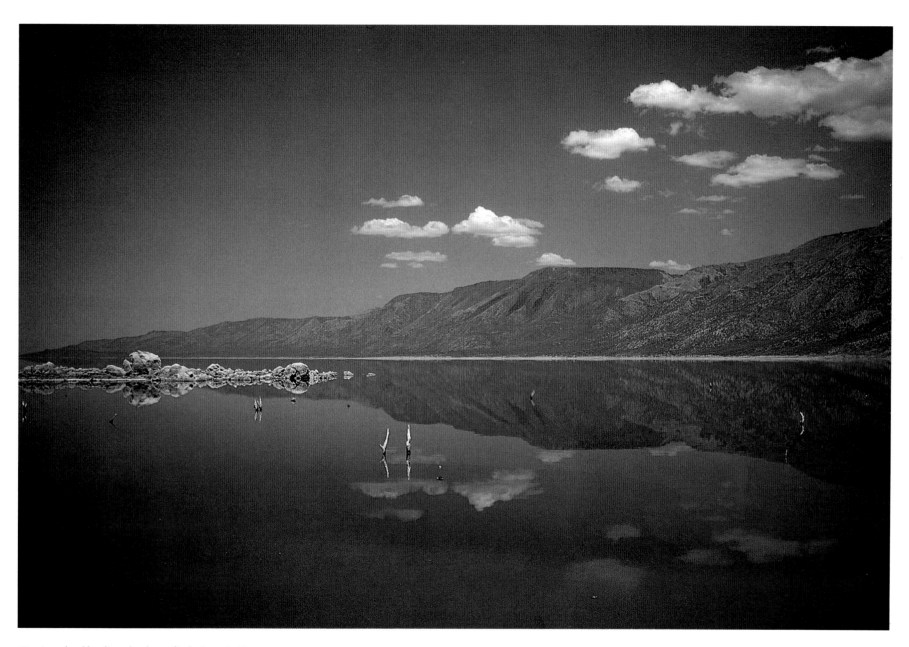

52 Lava boulders litter the shore of Lake Bogoria, Kenya.

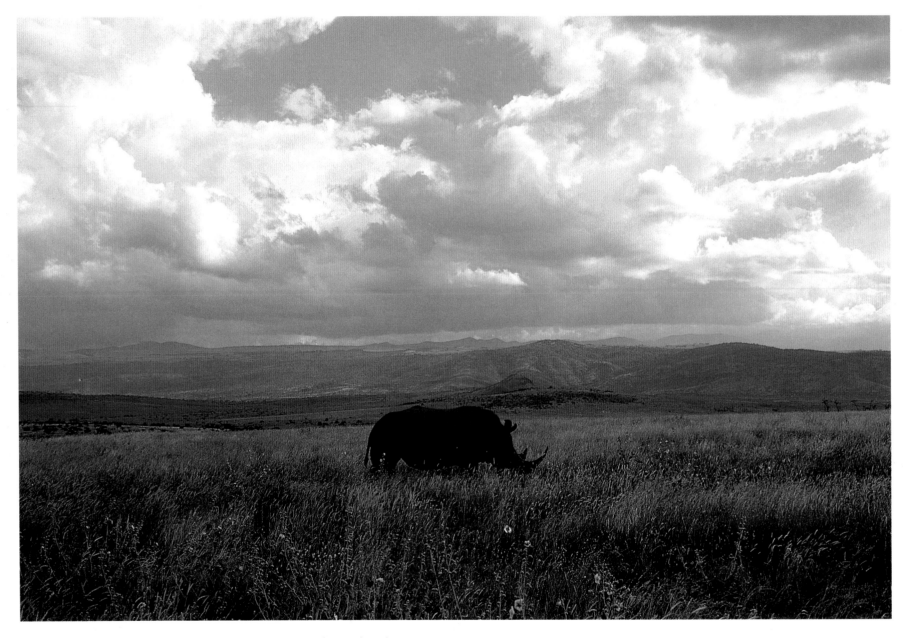

53 In 1970 there were 18,000-20,000 black rhinos in Kenya; now there are fewer than
500. Some live in large sanctuaries surrounded by high barbed-wire fences, guarded
individually by armed rangers.

54 (OPPOSITE) The elephant population of Kenya is dwindling. It is estimated that around
100,000 are killed illegally every year in Africa.

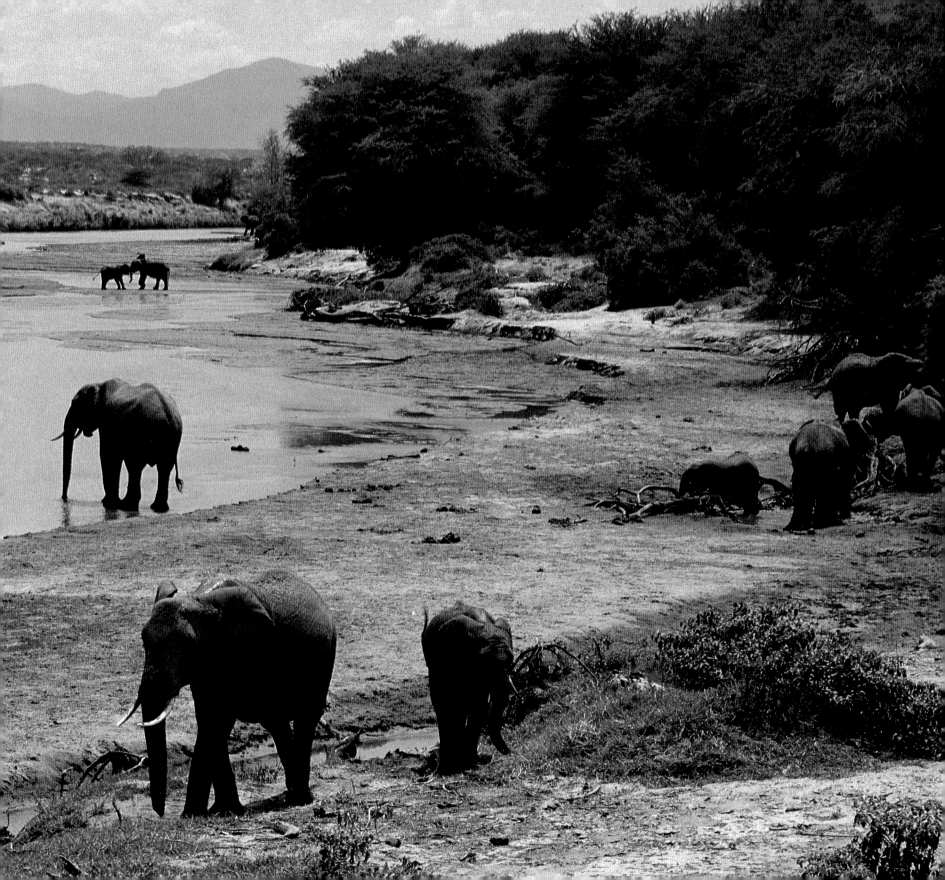

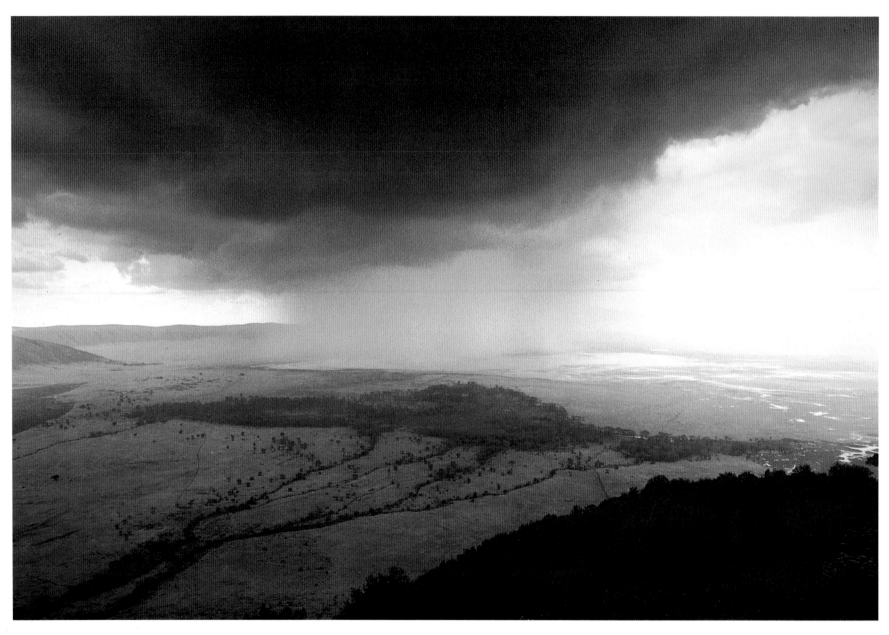

55 Lake Manyara is still home to large herds of elephant, and is known for its lions which
like to slumber in the branches of acacia trees.

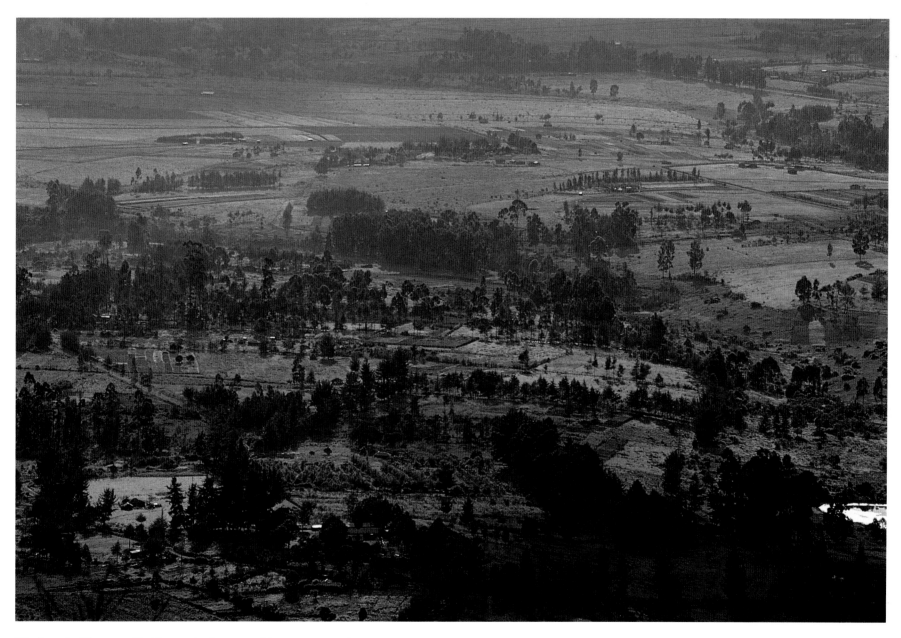

56 *Intensive Kikuyu smallholdings on land repossessed from Europeans after Kenya*
became an independent state.

57 (OVERLEAF) *Rocky granite outcrops in the Serengeti plains, called kopjes, have their own*
distinctive vegetation and wildlife.

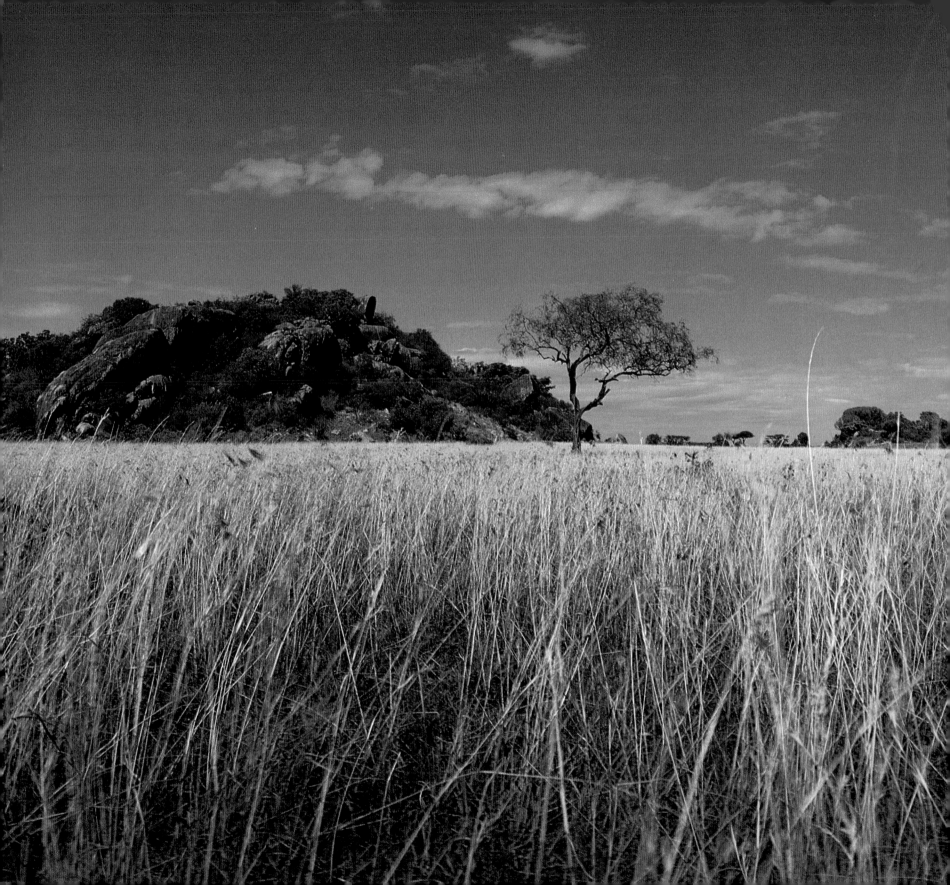

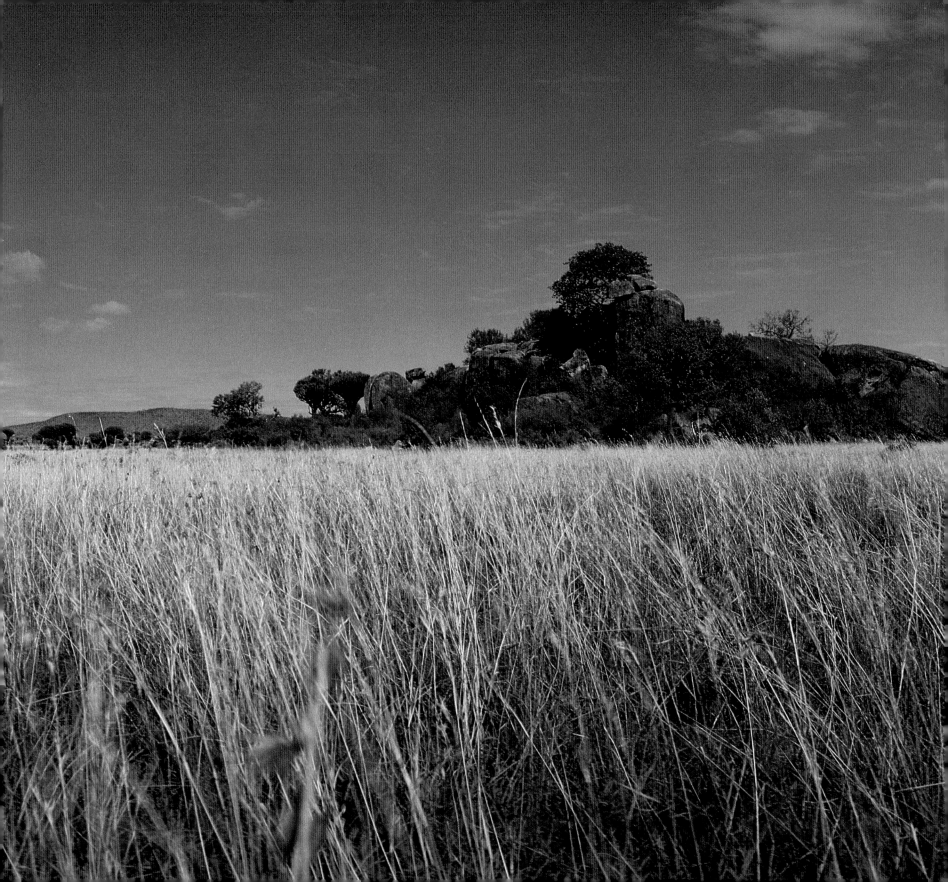

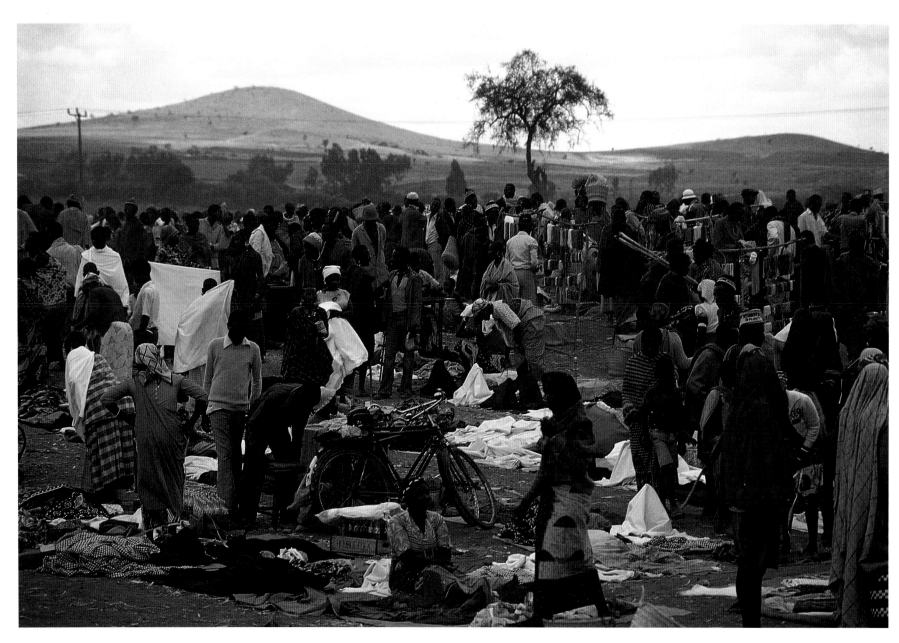

58 *Urbanized Masai bartering cheap Western goods near Arusha, Tanzania.*

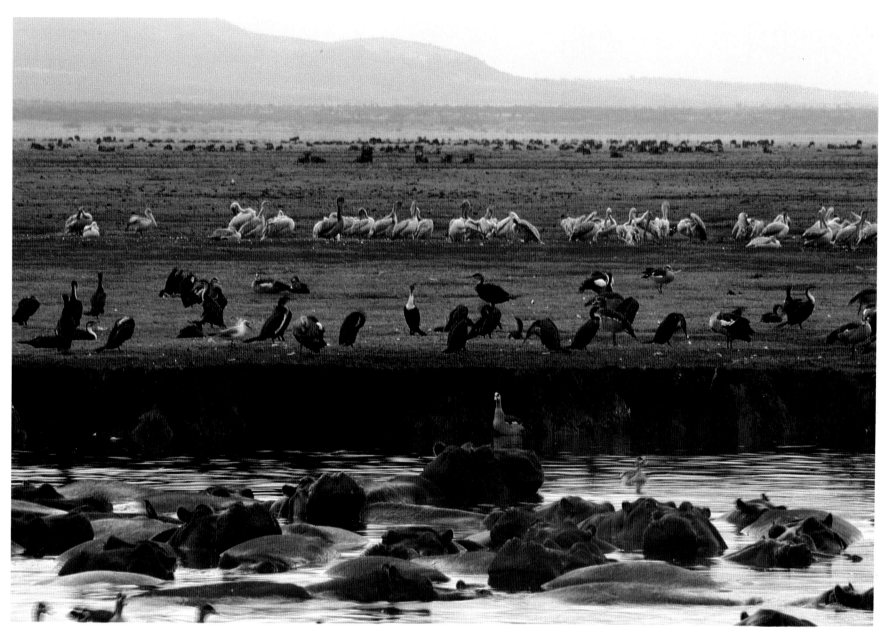

59 *Pelicans, cormorants and hippos, Lake Manyara. Hippos are born in the water (in which they can submerge for up to 6 minutes) but generally feed on land.*

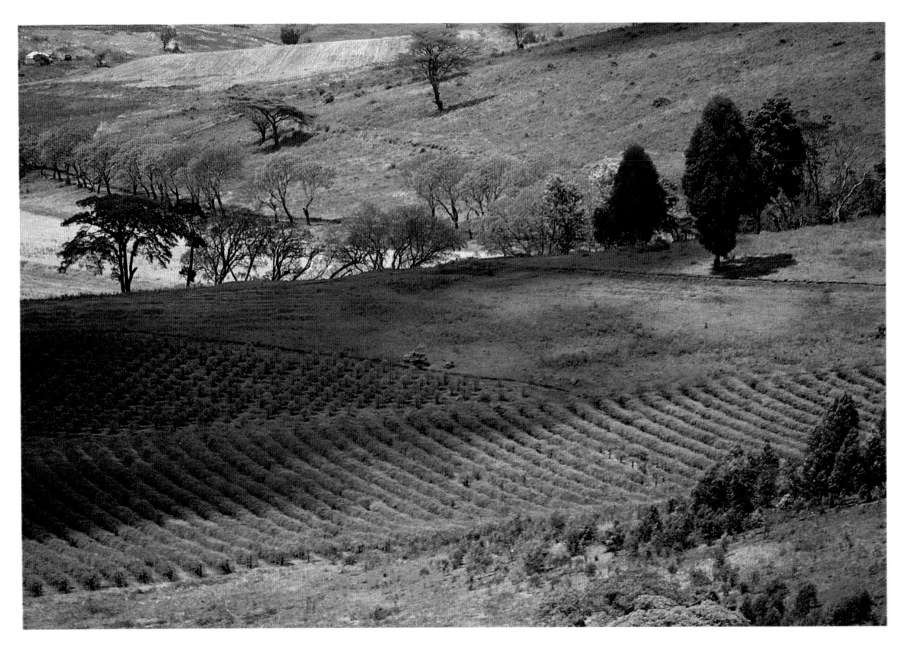

60 *Coffee plantation, Tanzania.*

61 *Masai Mara, Kenya's favourite wildlife park.*

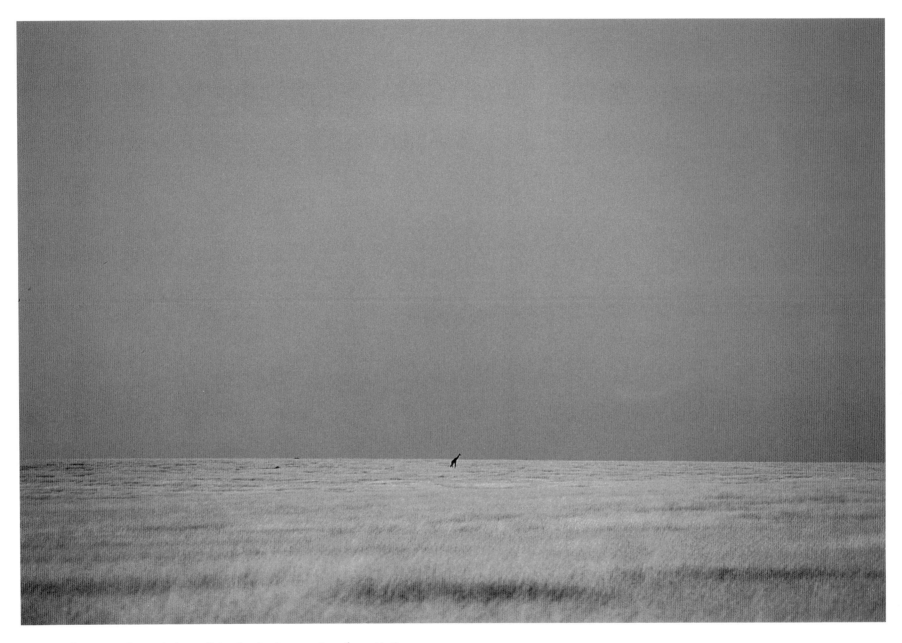

62 The tallest mammal on earth, the giraffe, is reduced to the proportions of an ant in the
vastness of the savannah.

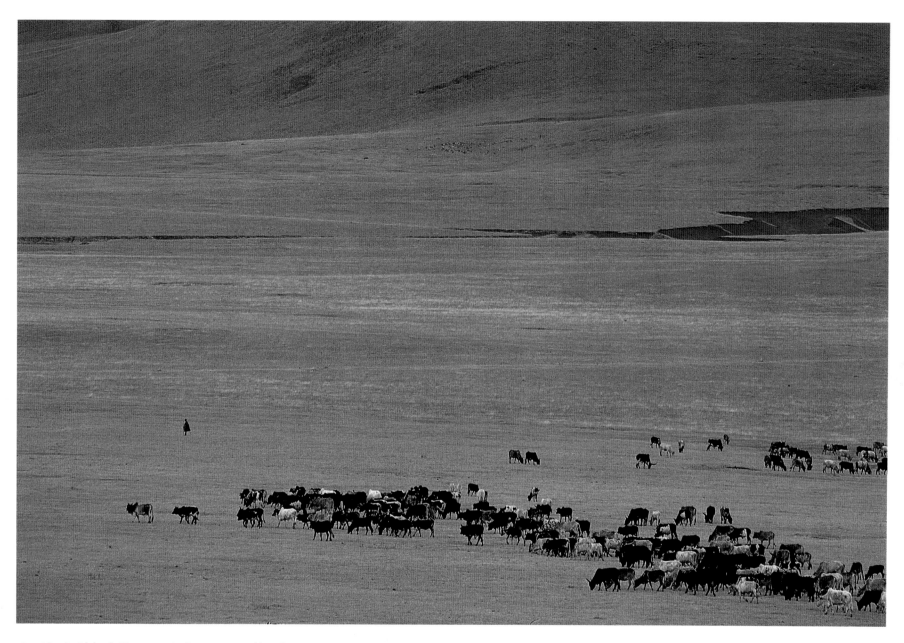

63 *Masai with herds, Tanzania. Cattle represent wealth to the Masai.*

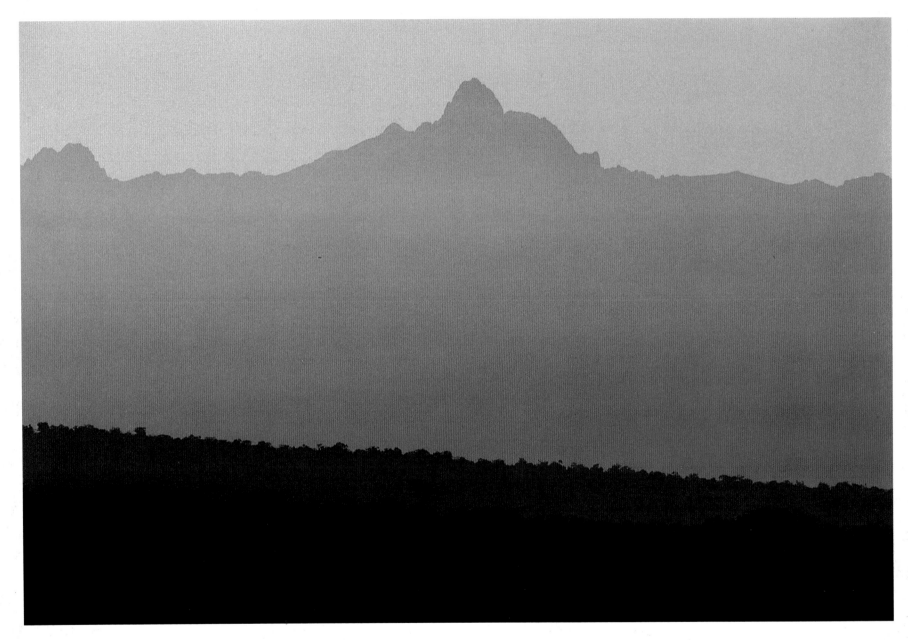

64 *Mount Kenya, once probably higher than Kilimanjaro, has been
reduced by erosion.*

65 *Mount Kilimanjaro, which Queen Victoria gave to her nephew, the
German Kaiser.*

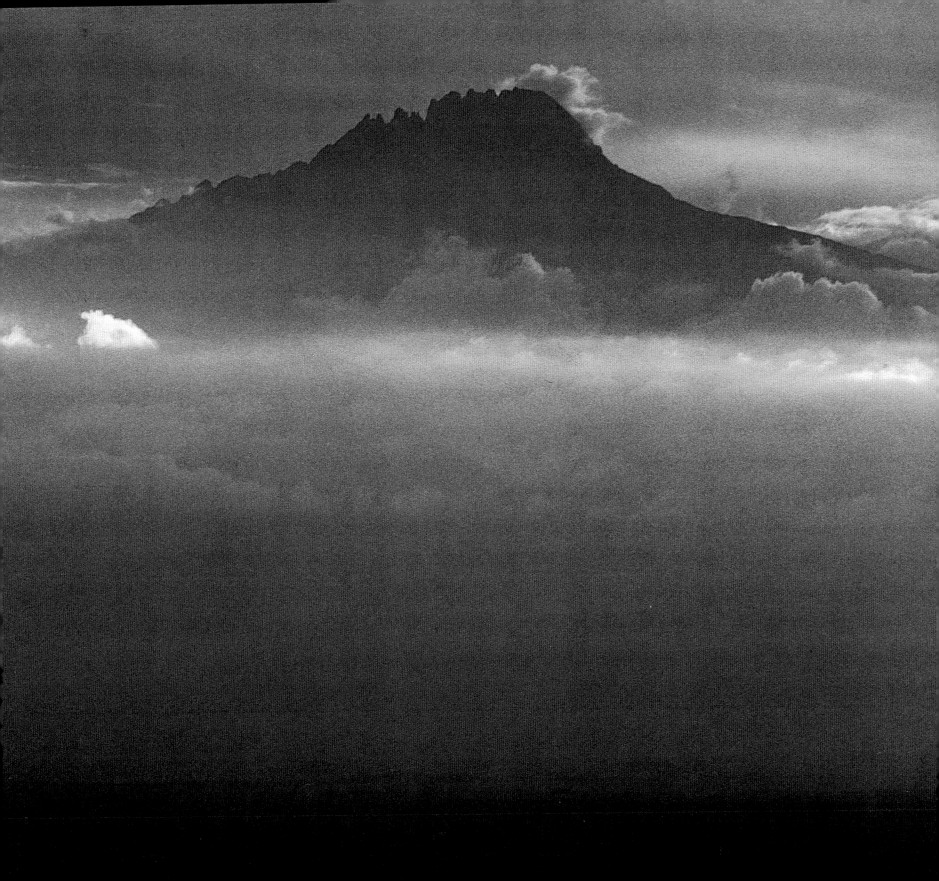

66 *Zebras at dawn, Serengeti. Like the wildebeest, zebras stay in herds for protection.*

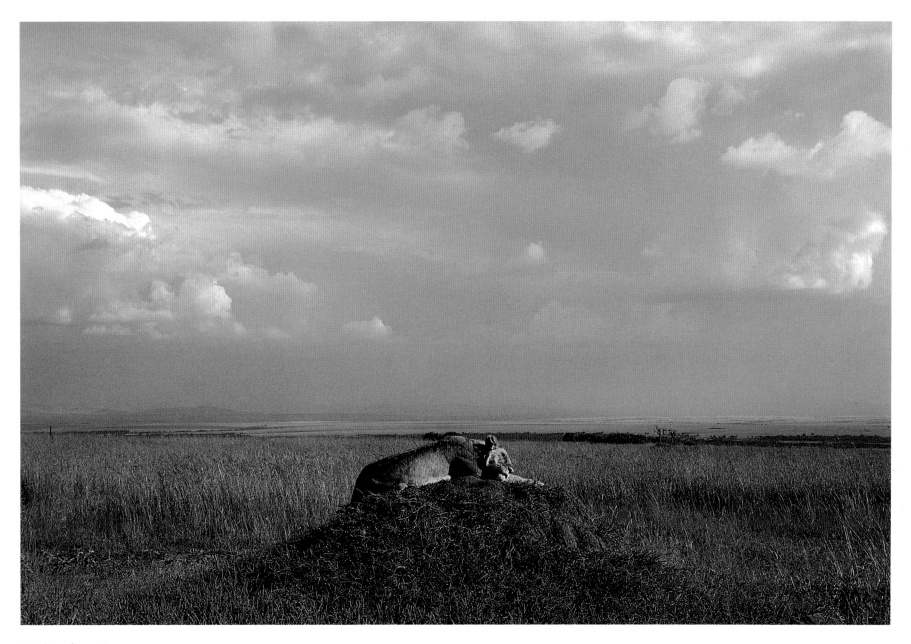

67 *Lion, Serengeti.*

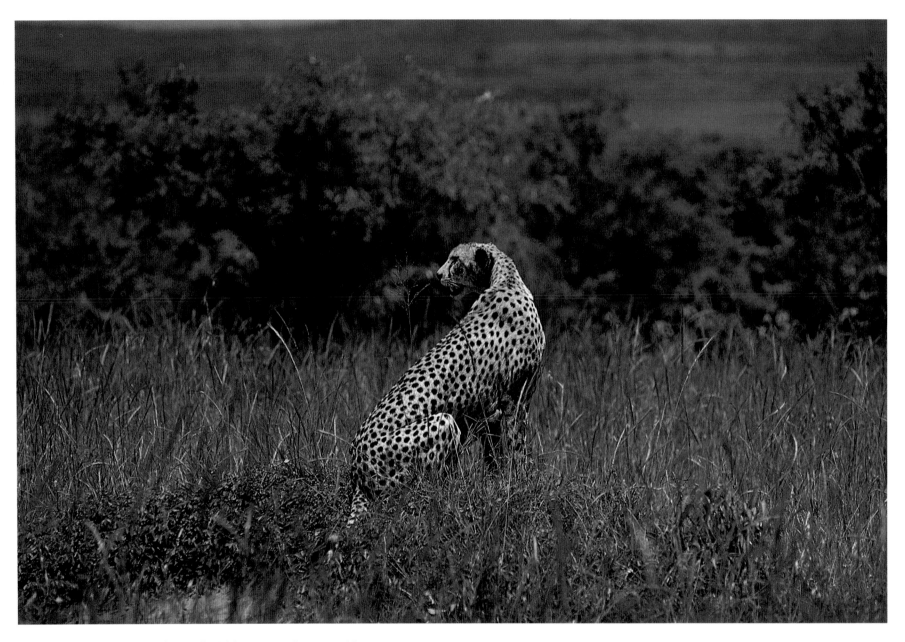

68 *Cheetah, Masai Mara. To Africans all wildlife is a source of instant wealth.*

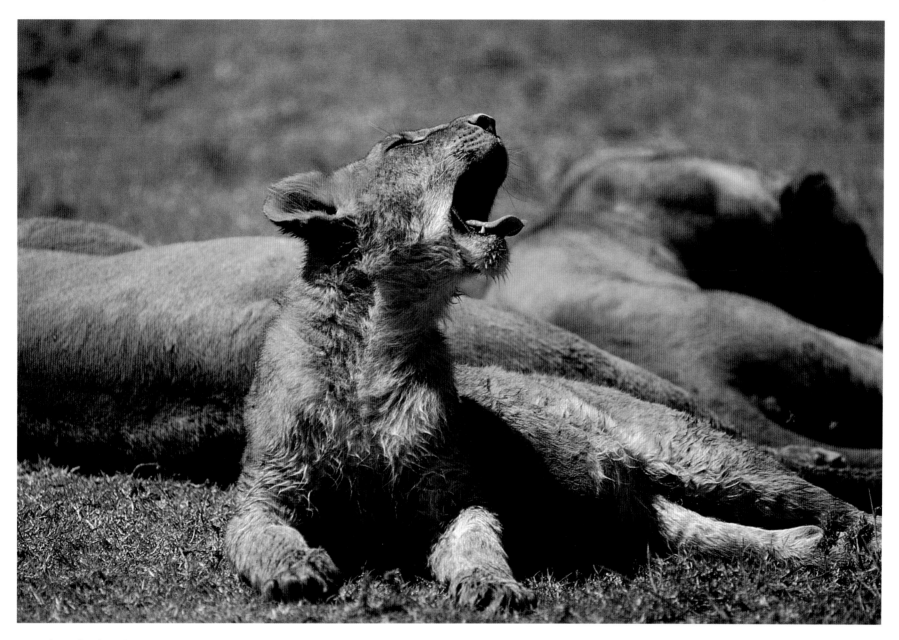

69 *A lion cub is dependent on its mother until it is two years old.*

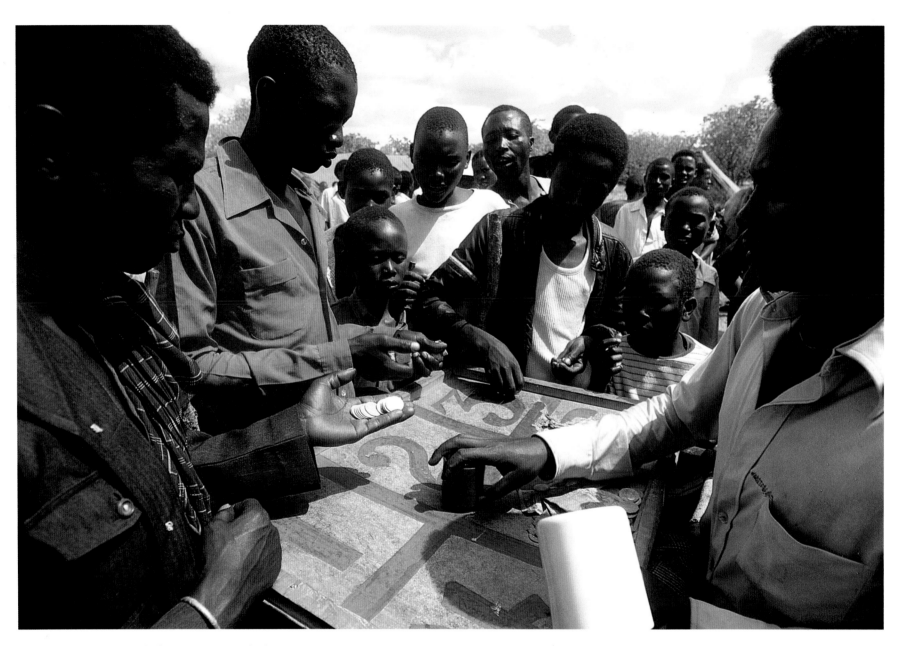

70 *Roulette, Tanzania. Each player puts money on his favoured number from 1 to 6. The game leader throws the dice and the number face up wins.*

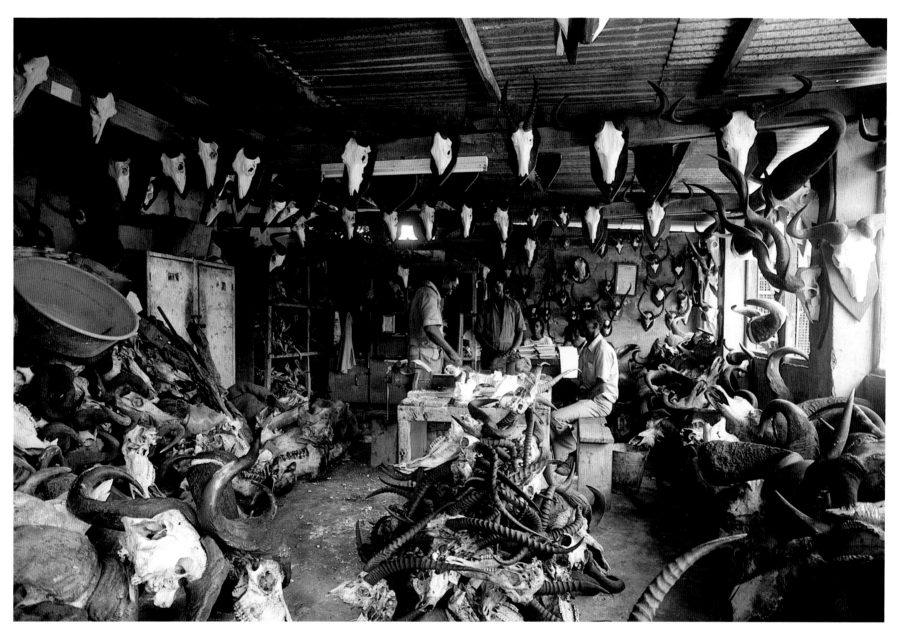

71 *A government-run shop in Tanzania preparing legally killed animals' heads as trophies for tourists and export.*

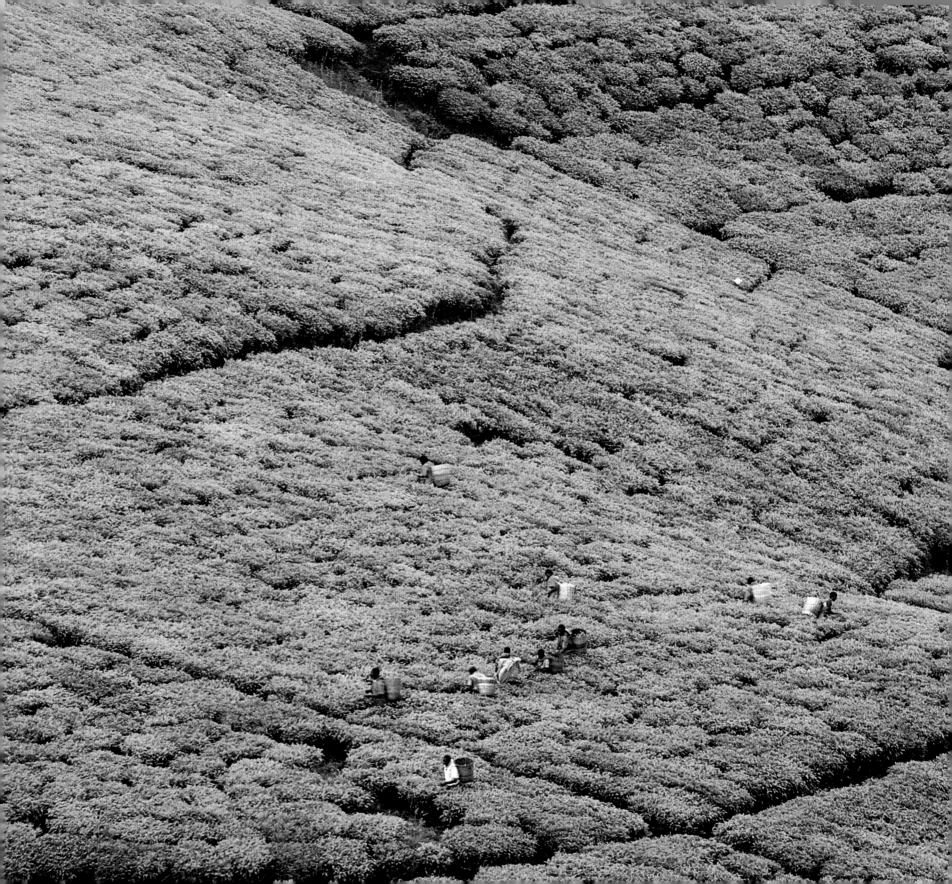

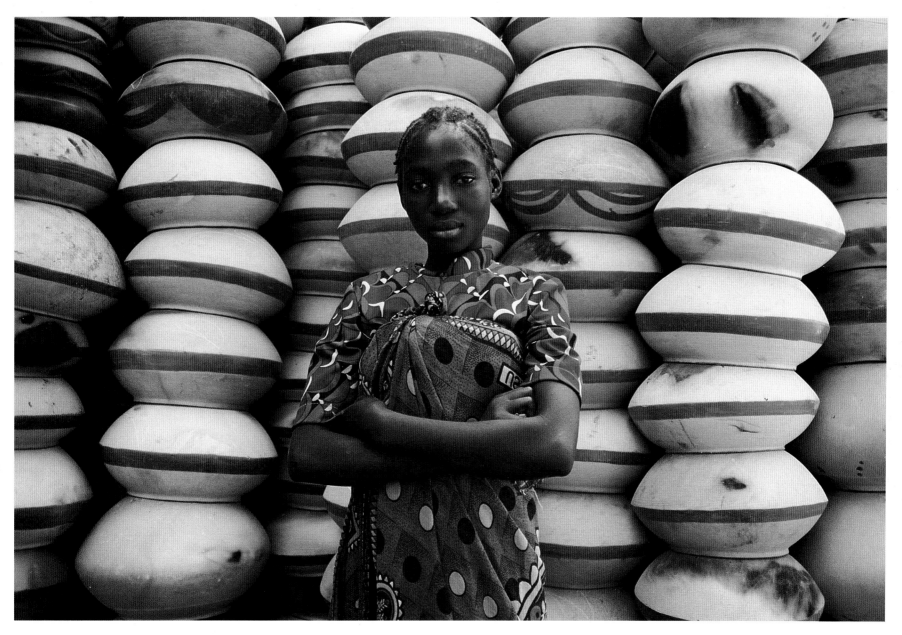

73 *Nyakusa girl. The pots are made by Tisi people on the eastern shores of Lake Malawi and transported by canoe to markets along the north shore and to villages locally.*

72 *Tea pluckers, southern Tanzania. The British company Brooke Bond has large estates here, still run by ex-patriots who live in isolated pockets of Englishness.*

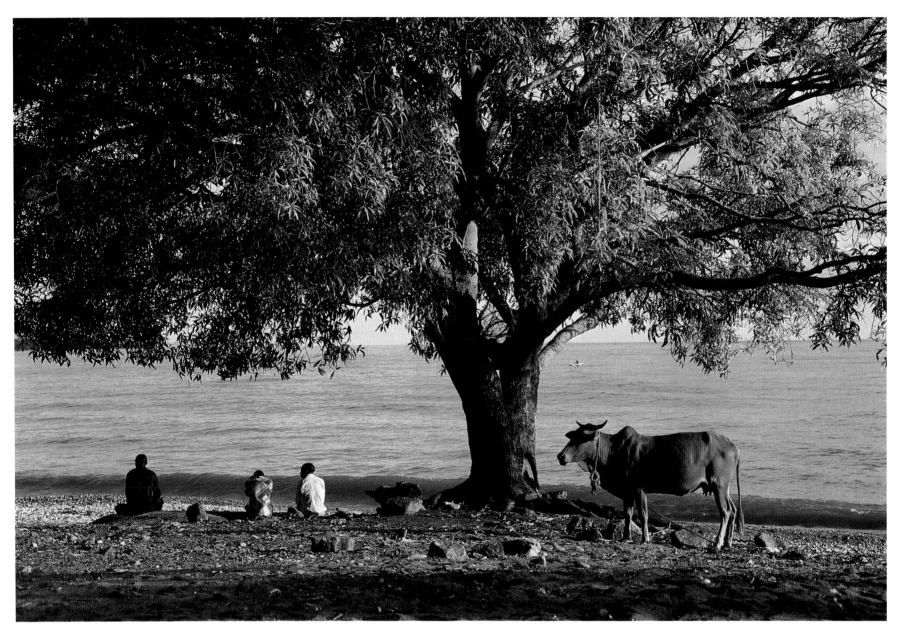

74 On the northern shores of Lake Malawi the Nyakusa live in a traditionally organized
and communal society.

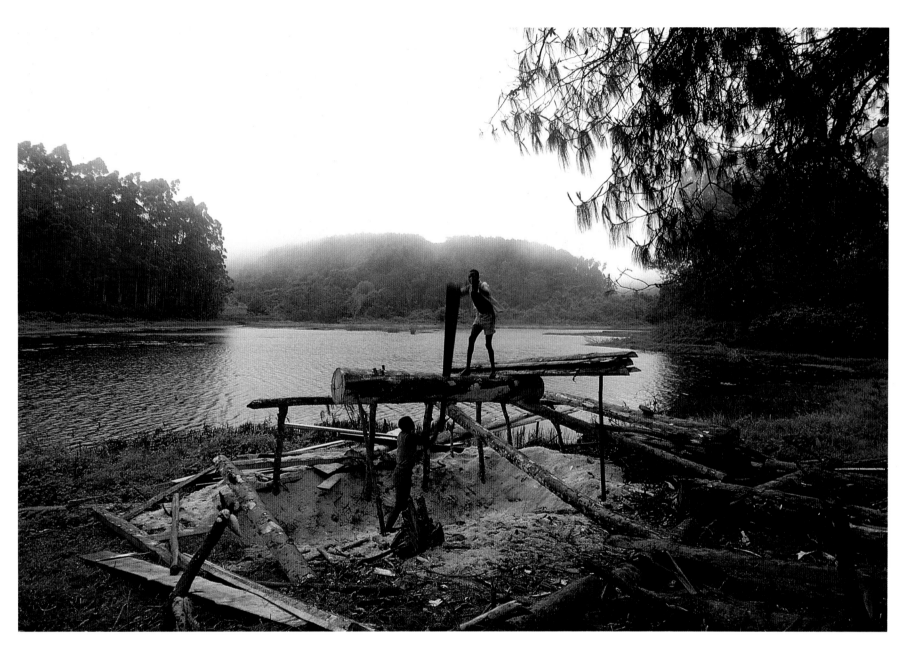

75 *Woodsmen, southern Tanzania. These men, sawing planks, are paid piecemeal for their work.*

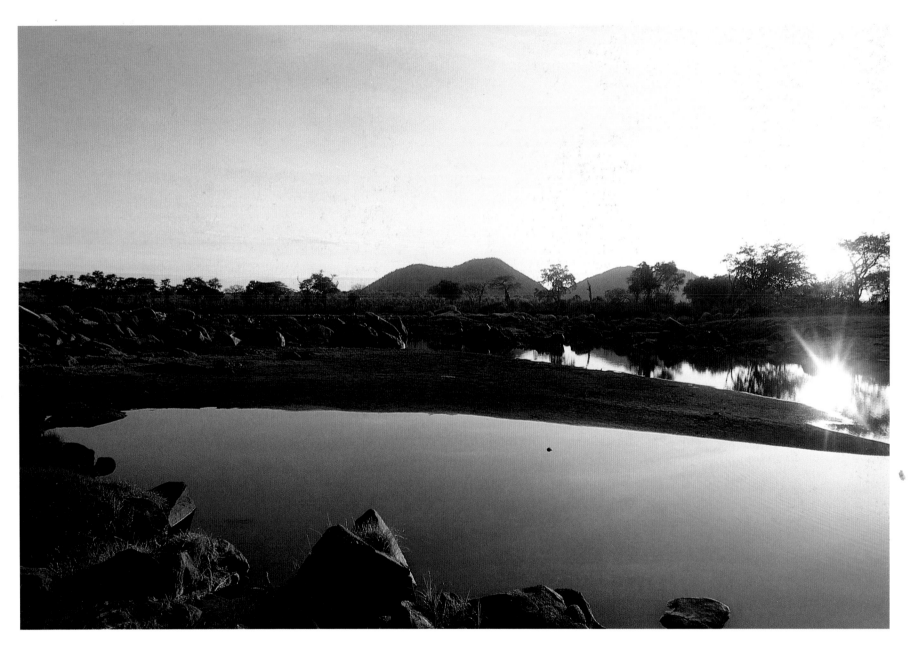

76 *Dawn, Great Ruaha River. Ruaha is a vast wilderness in central Tanzania.*

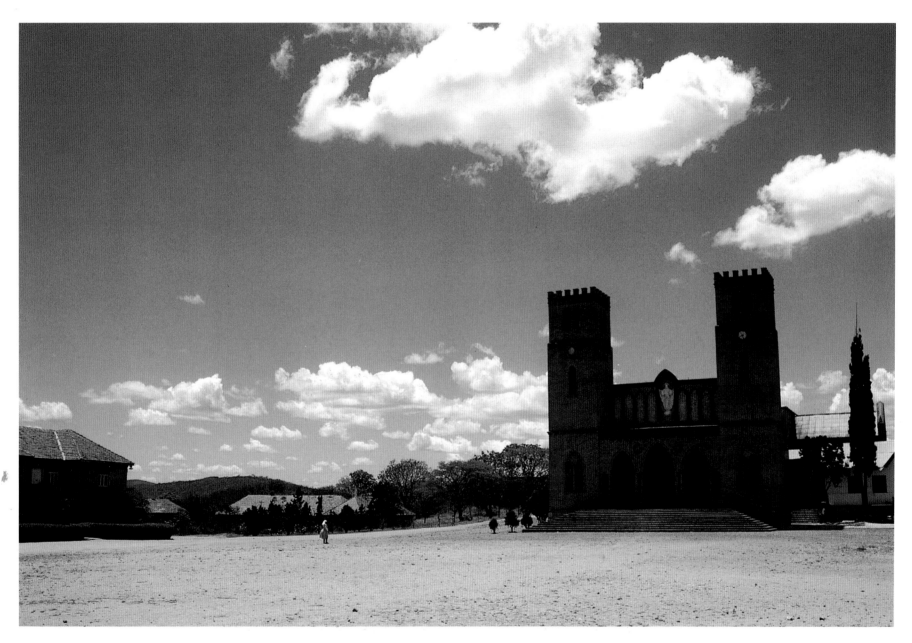

77 Italian mission, Toscemanga, Tanzania. Missions have existed in Africa since it was
first discovered by Europeans. Their activities have posed complex ethical and religious
questions but in general today they provide invaluable assistance and services for isolated
peoples in modern Africa.

78 (OVERLEAF) Cattle returning to the village, Lake Malawi.

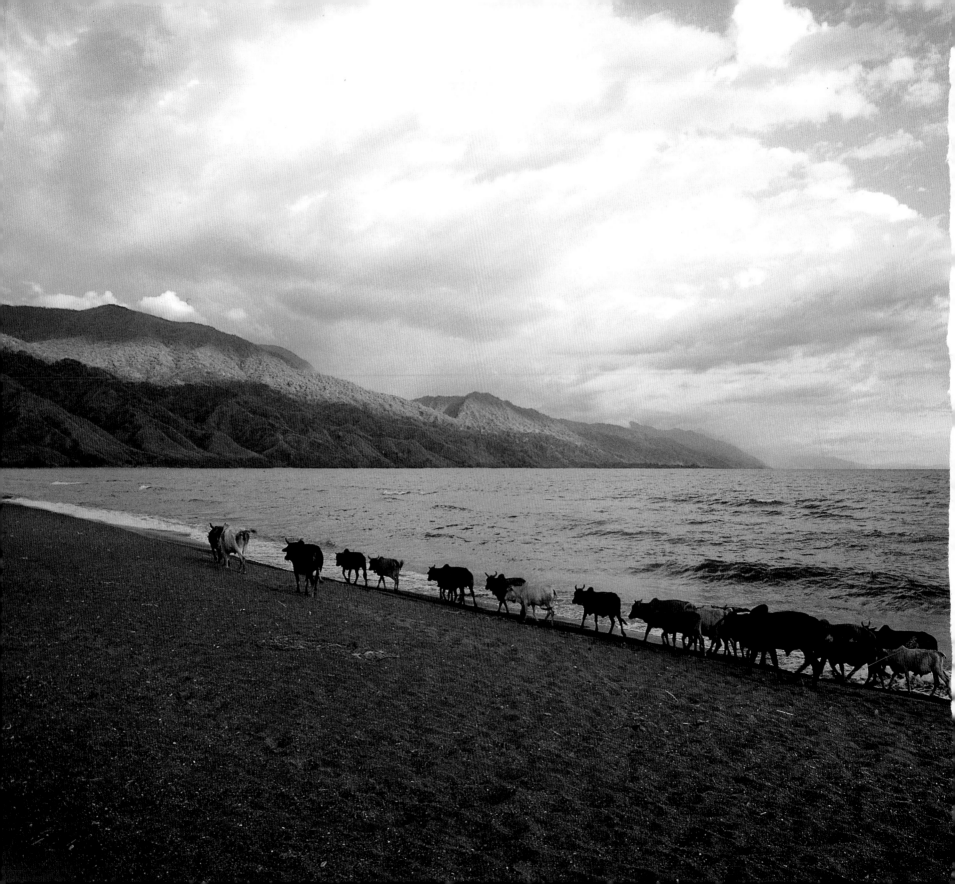